Paper Piece a
FLOWER GARDEN

BLOCKS AND PROJECTS TO MIX AND MATCH

Jodie Davis

Martingale™
& C O M P A N Y

ACKNOWLEDGMENTS

Thanks to Tammy Silvers for her sewing expertise in making the *Nesting in the Dogwoods* quilt top and to the staff and shoppers at Tiny Stitches in Roswell, Georgia, for helping me over a few "what's next?" hurdles, not to mention the fabric, oh the fabric!

■ ■ ■

DEDICATION

To Christine and Cherokee

For friendship born of treks to the Shoals and trillium discoveries. Domino smiles to both of you.

CREDITS

President . Nancy J. Martin
CEO . Daniel J. Martin
Publisher . Jane Hamada
Editorial Director Mary V. Green
Editorial Project Manager Tina Cook
Technical Editor . Laurie Baker
Copy Editor . Pamela Mostek
Design and Production Manager Stan Green
Illustrators Robin Strobel, Laurel Strand
Cover Designer . Trina Stahl
Text Designer Julia Kartawidjaja
Photographer . Brent Kane

No part of this product may be reproduced in any form, unless otherwise stated, in which case reproduction is limited to the use of the purchaser. The written instructions, photographs, designs, projects, and patterns are intended for the personal, noncommercial use of the retail purchaser and are under federal copyright laws; they are not to be reproduced by any electronic, mechanical, or other means, including informational storage or retrieval systems, for commercial use. Permission is granted to photocopy patterns for the personal use of the retail purchaser.

The information in this book is presented in good faith, but no warranty is given nor results guaranteed. Since Martingale & Company has no control over choice of materials or procedures, the company assumes no responsibility for the use of this information.

That Patchwork Place® is an imprint of Martingale & Company™.

Paper Piece a Flower Garden: Blocks and Projects to Mix and Match
© 2001 by Jodie Davis

Martingale & Company
20205 144th Avenue NE
Woodinville, WA 98072-8478
www.martingale-pub.com

Printed in China
06 05 04 03 02 01 8 7 6 5 4 3 2 1

Library of Congress Cataloging-in-Publication Data
Davis, Jodie.
 Paper piece a flower garden: blocks and projects to mix and match / Jodie Davis.
 p. cm.
 Includes bibliographical references.
 ISBN 1-56477-356-6
 1. Patchwork—Patterns. 2. Quilting. 3. Gardens in art. I. Title

TT835 .D374695 2001
746.46'041—dc21
 2001016248

CONTENTS

PREFACE

Building a flower garden quilt is much like creating a real flower garden. It's all about color and texture and placement and watching things grow into place. In fact, while nurturing my ideas for this book into fabric, my then fiancé, Bill, and I were creating a garden at our new house with a similarly blank canvas—a bare lot recently carved from the woods. Both the garden book and the outdoor garden shared another similarity—a deadline. The difference is that we'll celebrate the garden's inauguration yearly on the anniversary of our wedding day, April 16.

Both gardens also started with a general plan— the big picture. Outside we made decisions about the placement of the flower beds, large trees, and garden fixtures. Inside the design walls were as bare as our clay lot, but the flowers were popping up in my head as fast as I could draft them on the computer screen.

With the plan established, we started planting the bones of the outside garden in the unforgiving Georgia clay. Flowering and screening trees were installed, the deck was designed and built, and the existing deck turned into a screened porch. Then it became obvious that a pond needed to be dug adjacent to the deck. Next came an arbor for my grand entrance—a front door for our backyard garden room.

We planted honeysuckle and built a trellis on the deck for it to climb. It was to be the spot where we'd be married. Spring finally arrived, and we spent days planting annuals and perennials to make our garden wedding colorful.

Back inside, blocks of color were slowly emerging, accompanied by the hum of my trusty Bernina. Flowers bloomed on my design walls beside the nearly finished wedding dress. My indoor garden was coming to life just like the one I enjoyed planting outdoors.

Sitting here writing this, I feel much as I did after our wedding. All the months of sewing and digging, turning vision into reality, seem deceptively easy in hindsight. Bidding the last guests farewell after the wedding, watching them cross the deck, pass the pond, and disappear through the arbor is not unlike seeing my book carried off in the trusty hands of Alan, our Federal Express man. The happiest period of my life, with its hopes and anticipation, frustration, and the chaos of a wedding, is all stitched into these quilts. Hard work and lots of love—this is what quilts, gardens, and marriages are made of.

INTRODUCTION

You will find everything you need to know to create your flower garden quilt in the pages of this book. Starting with the basics of paper piecing, you'll then progress to the ins and outs of paper piecing curves. Finishing instructions complete the primer section and provide you with the knowledge to complete your quilt.

Equipped with these basics, you're ready to begin sewing. Full-size patterns and piecing keys for *each* of the thirty-six blocks are presented, along with a color photo of each finished block. Complete, detailed instructions guide you through the creation of eight ever-blooming quilts.

Finally, you won't want to miss the "Resources" section starting on page 95. You'll find tried-and-true mail-order and Internet fabric and quilting supply sources, plus some of my favorite quilting sites chock-full of quilting information.

Now let's grow our garden!

PAPER-PIECING PRIMER

Defining the Pattern Markings

THE PATTERNS for the blocks in this book are found on pages 16–65. They are full-size with ¼" seam allowances added. As you look at each pattern, you will notice several things:

- Each pattern consists of at least one unit. If the pattern has more than one unit, each subunit is labeled with a letter. Subunits are pieced separately and then joined in the letter order indicated in "Joining Sequence," which appears on the same page as the pattern.

Completed block

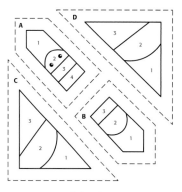

Subunits

5

- Each unit of the pattern is numbered. The numbers indicate the sewing sequence for the fabric pieces.
- Each pattern has dashed and solid lines. Dashed lines represent cutting lines and solid lines represent sewing lines.

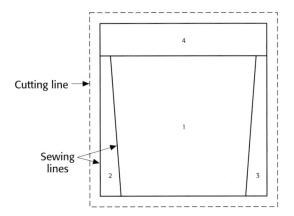

- Some patterns are the mirror image of the block you see in the photo. This is because the blocks are sewn from the marked side of the paper foundation, which is the wrong side of the finished block. For symmetrical blocks the patterns and finished blocks look the same, but for asymmetrical blocks the finished blocks are mirror images of the patterns.

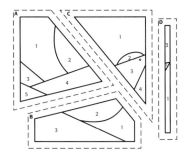 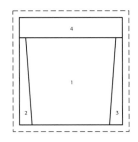

Asymmetrical block

Symmetrical block

Selecting a Foundation Material

BLOCK PATTERNS for paper piecing are transferred to a foundation material. The foundation provides the sewing lines as well as stability for sewing and piecing blocks together. It can be either permanent or temporary, depending upon the desired result and whether you plan to work by hand or machine.

Permanent foundations are usually made of fabric. They remain in the completed quilt, adding an extra layer. Because curved piecing creates folds and gathers of fabric, the added bulk of another layer—the foundation—makes a permanent foundation a poor choice for this technique.

Temporary foundations, on the other hand, are removed before you complete the quilt, thereby creating no bulk in the seams and making them a good choice for curved paper piecing.

Many types of paper can be used as temporary foundations. Newsprint is the most economical, but slightly more expensive materials such as tracing paper, vellum, and typing paper offer a few important characteristics that make the additional cost worthwhile. Both vellum and tracing paper are semitransparent, allowing you to see the fabrics through the paper. This is a huge benefit when placing fabric pieces. Weighing cost and benefit, inexpensive typing paper is my current favorite, although you cannot see through it as easily as vellum and tracing paper. It tears away from the stitching more easily than newsprint, which you will appreciate when the time comes to remove the paper from your blocks.

Transferring the Patterns

TO REPRODUCE the patterns, trace or photocopy them from this book onto a temporary foundation such as newsprint, tracing paper, vellum, or typing paper. Leave about ½" between pattern units or individual patterns. When tracing use a ruler to ensure accuracy. Be sure to label each pattern unit with the appropriate letter and transfer the piecing sequence numbers to each unit. If you choose to use a photocopy machine to reproduce the patterns, watch out for distortion. To test the precision of the copy machine, make one copy of the pattern and measure it to be sure the size matches the original. Cut out the pattern pieces after you finish copying them. Be sure to cut them apart outside the dashed lines.

Two of the quilts, *Garden Sampler* and *Loving Life in the Pond*, use mirror images of some of the block designs. To make a mirror image block, transfer the design to tracing paper as described above, then turn the paper over and retrace the lines and numbers (reverse the numbers so that they are readable). Transfer the reversed design to the foundation material and mark it with an *M* to indicate that it is a mirror-image pattern.

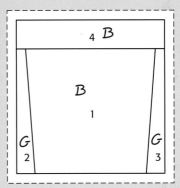

Precutting the Block Fabrics

UNLIKE TRADITIONAL piecing, the fabric pieces used in paper piecing do not need to be cut the exact size of the areas they will fill. Simply cut the desired fabric into a chunk that is at least ½" larger on all sides than the area it is to cover. Excess fabric is trimmed away after the piece is stitched to the next fabric piece in the sequence. If the piece that is trimmed away is large enough, you can always use it in another area. While this may seem like a waste of fabric, it is much better than the alternative—the dreaded seam ripper.

One of the beauties of paper piecing is that the foundation stabilizes the fabrics, and, as a result, it is unnecessary to strictly follow grain-line rules when cutting fabric. In normal template or rotary-cut piecing, it is imperative that the outside edges of blocks are cut on the straight of grain; if they are cut on the bias the unstable pieces stretch and cause problems when they are pieced together. There is one important point to remember, however, with paper piecing. Leave your foundation in place until you sew your blocks together so that the fabric does not stretch.

Preparing to Sew

SET YOUR machine for a stitch length of eighteen to twenty stitches per inch. The short stitch length creates a stronger stitch that won't come apart when you tear the fabric away, and the closely spaced perforations also facilitate the tearing away of the paper.

Choose your thread according to the fabrics selected. Gray is a good choice for most fabrics, while a light beige or even white may work best for light fabrics.

Basic Paper Piecing

THE FOLLOWING is a step-by-step overview for paper piecing a block. For information about paper piecing curves, please refer to the next section, "Paper Piecing Curved Seams," on page 10. Please note that all of the blocks in this book begin with a base piece of fabric, which is referred to as *piece 1*. This fabric is cut to cover the area marked *1* on the pattern. Other pieces are then stitched to this base fabric.

1. Transfer each unit of the desired pattern onto the foundation material.

2. Using a fabric gluestick, apply a small amount of glue to the right side (unmarked side) of section 1 on the paper foundation. From the fabric indicated for section 1, cut a piece that is at least ½" larger than section 1 on all sides. Place the fabric piece, right side up, over section 1 so that it is completely covered. Press the fabric in place with your hand. *Note:* You may pin the fabric in place rather than using the gluestick.

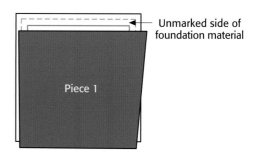

3. Cut a piece of fabric for section 2. With right sides together, place piece 2 against piece 1 so that the majority of piece 2 is over section 1. Leave about ½" of fabric extending into the section marked *2*. Working from the marked side of the foundation, stitch along the seam

line between section 1 and section 2. Begin and end the stitching several stitches beyond the ends of the line.

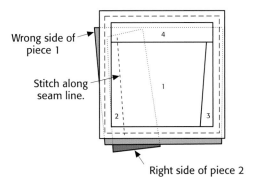

Wrong side of piece 1

Stitch along seam line.

Right side of piece 2

TIP

Though I usually use my ¼" presser foot for all quilt-related sewing, you may find that an open-toe foot helps you see the line as you sew.

4. Fold down piece 2 to be sure it covers the section marked *2* in the pattern when it is pressed into place. Flip the piece back up and trim the seam allowance to ¼".

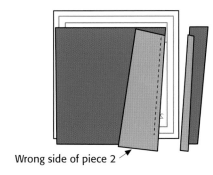

Wrong side of piece 2

5. Fold piece 2 over the seam and press it in place.

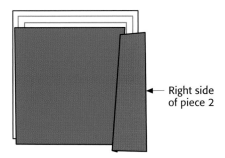

Right side of piece 2

TIPS

- When pressing use a hot, dry iron so that you do not distort your block. To avoid shrinking the foundation or getting ink from the foundation onto your iron and your fabric, press only on the fabric side of the blocks.

- To avoid transferring ink from the foundation to your ironing board cover, place a paper towel or piece of felt between the ironing board and the block.

6. Continue to cut and stitch fabric pieces for the remaining sections in the numerical order indicated. Leave at least ½" around the outer edge of each fabric piece for seam allowance.

7. If the block consists of more than one unit, complete the remaining units in the same manner. Add the pieces in numerical order.

8. Lay the unit or block, fabric side down (marked paper foundation up), on a cutting mat. Using a rotary cutter and ruler, trim the edges of the block unit(s) along the dashed lines. This leaves a ¼" seam allowance around the block. Make sure you cut through both the foundation and the fabric.

9. To join subunits into a block, refer to "Joining Sequence" in the block instructions to pin the subunits together in the correct order. Stitch along the solid line. Remove the paper in the seam allowances only. Press the seam(s) open.

NOTE: *Embellishment details are added after the block or quilt is quilted. Refer to "Details" in the block directions for embellishing each block.*

TIP

Leave the paper foundation(s) in place until after the quilt top is completed. Blocks are easier to align this way and will not become distorted by the tearing process.

Paper Piecing Curved Seams

PAPER PIECING curves is truly easy. The only difference between curved and traditional straight-line paper piecing, other than the obvious fact that you're sewing on a curved line rather than a straight line, is that in curved paper piecing the fabric can't lie flat; therefore, the excess fabric has to be pleated. You can't just flip the fabric back as you can in straight-line paper piecing. Pleats create great visual and textural interest on the quilt top, and they don't limit the paper-piecing technique. In fact, there is no reason why curved paper piecing cannot be used to make bed quilts. Even with the little pleats created by this technique, the fabrics lie flat.

TIP

For a perfect match every time, use a pin to help you match the seams of your subunits. With the two subunits placed right sides together and working from the wrong side of the top unit, poke a pin into the corner of the stitching line at one end of the seam you are matching.

Hold the pieces together as you poke the pin into the bottom piece to make sure the pin comes out at the corner point of the bottom subunit. It may take a few tries, but by peeking underneath you'll get the point exactly.

Pinch the subunits together, matching the raw edges along the seam. Use a pin or two to secure the pieces together. Remove the corner-matching pin. Sew the seam.

The following steps explain the process of paper piecing curves.

1. Follow steps 1–4 of "Basic Paper Piecing" on pages 8–9 to prepare the pattern piece and stitch the two pieces together along the curved line. To allow for pleating the excess fabric, cut the fabric pieces for the curved sections approximately 1" larger than you would for normal paper piecing. Trim the seam allowance to ¼".

Position fabric piece in place for curved section.

Stitch along curved line.

Trim seam allowance to ¼".

2. Fold piece 2 over the seam. Fold pleats, either toward or away from the center, into the curved fabric piece to make it lie flat. It does not matter which way you fold the fabric as long as you consistently fold the pleats the same way in each block. Fold the pleats one at a time, placing a pin in each pleat as you go. A small curved piece with a tight curve may require 2 pleats. For a longer curve, make 4. Refer to the block photos for guidance.

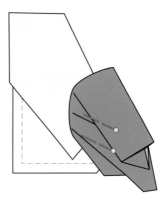

3. Working on the marked side of the paper foundation, machine baste in the seam allowance between the solid and dashed lines to secure the tucks, removing the pins as you stitch. Use the longest stitch available; you'll be thankful later when you have to tear the stitches out to remove the paper.

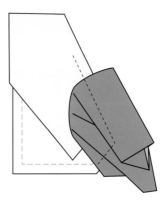

4. Add any remaining pieces in numerical order, referring to "Basic Paper Piecing" on pages 8–9 for straight-line pieces.

5. Refer to steps 8 and 9 of "Basic Paper Piecing" on pages 9–10 to trim the edges of the block piece(s) and join the block parts if needed.

The "V" Trick

ALWAYS ON the lookout for an easier way to do things, I used a technique that eliminates a subunit for the picket fence block, thereby making the picket fence a one-unit block. To do so, I stitched the points at the top of the pickets with a "V" seam, then folded back the fabric, forming what looks like a prairie point. It doesn't work for all situations, but for the two quilts in this book the added dimension is a plus.

1. Refer to "Basic Paper Piecing" on pages 8–9 to stitch the vertical strips of white and green fabrics together to form the pickets.

2. With right sides together, stitch a green rectangle to the "V" portion of the fence pattern. Trim the seam allowance to ¼".

3. Fold one side up along the stitching. Fold the remaining side over the first side. Pin the piece in place.

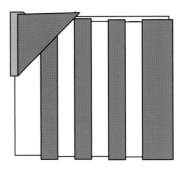

4. Repeat for the remaining "Vs". Baste in place along the straight upper edge of the pattern.

Finishing Your Quilt

Assembling the Quilt Top

Now that all the individual elements of your garden quilt have been completed, it's time to bring them together. The following steps explain how to assemble the quilt top.

1. Refer to the layout diagram for the particular quilt you are making in order to lay out the blocks and any other required fabric pieces in the proper order. Sew the blocks together along the outer solid line on the foundation in the order indicated on the instructions. After each seam is stitched and before it is pressed, remove the foundation paper *from the stitched seam allowance only.* To do so, gently tear the paper

as if you were tearing stamps. A gentle tug against the seam will give you a head start in loosening the paper foundation from the stitching. Press the seam allowances open.

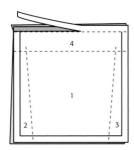

2. Add any borders to the quilt top. Remove the remaining paper foundations from the backs of the blocks.

3. Gently press the completed quilt top.

Preparing for Quilting

There certainly is something to that old adage that practice makes perfect. Though my quilting is far from perfect, my effort to improve my machine quilting has reaped significant results in the last year. Jumping in and doing it has turned what used to be a chore into fun!

Before you begin to quilt, prepare your quilt by marking the top with the quilting design (although all of the quilts in this book were quilted free-form with no marked lines) and layering it with backing and batting. Follow steps 1–4 to prepare your quilt and steps 5 and 6 for quilting.

1. Mark the quilt top with the desired quilting design.

2. Cut the batting and backing 4" to 6" larger than the quilt top. This will give you 2" to 3" extra on each side of the quilt.

3. Lay the backing wrong side up on a flat surface. Place the batting over the backing. Center the quilt top right side up on top of the batting and backing.

4. Working from the center out, baste the layers of the quilt "sandwich" together with thread or safety pins.

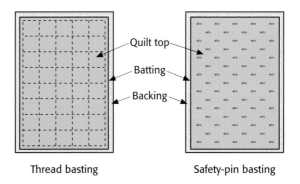

Thread basting Safety-pin basting

5. Quilt the top as desired or as indicated in the project directions.

6. When you are finished quilting, remove all basting stitches or any remaining safety pins.

Making and Applying Binding

In the instructions I have given the width of the binding strips for each quilt. Because these are small quilts and will not suffer heavy use the way a bed quilt would, I have economized on fabric by using binding strips cut on the straight of grain rather than on the bias grain. The only exception is *Loving Life in the Pond* (page 74). I wanted to take advantage of the stripe effect of the fabric, so I cut it on the bias grain. If you want bias binding, be sure to buy extra fabric.

To make straight-grain binding, simply cut strips from the lengthwise or crosswise grain of the fabric. Join the ends to make one long, continuous strip.

To make bias binding, I used the flat-cut method. Make a bias cut starting at one corner of the fabric. Then cut bias strips the desired width, measuring from the edges of the initial bias cut.

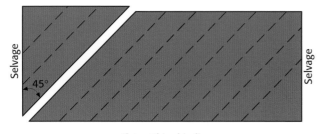

Flat-cut bias binding

Join the bias strips as shown to make one long, continuous strip. Press the seam allowances open.

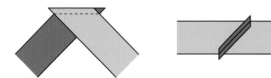

BINDINGS WITH MITERED CORNERS

Once you make your binding strip, the following binding method—it creates mitered corners—is one way to attach it to your quilt.

1. Trim the batting and backing even with the quilt top.

2. Cut one end of the binding strip at a 45° angle. Press the cut end under ¼". Wrong sides together, press the binding strip in half lengthwise.

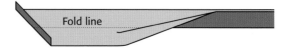

Fold line

3. Place the binding strip along one edge of the right side of the quilt top, matching raw edges. Leaving the first 2" or so of the binding free, stitch the binding to the quilt using a ¼" seam allowance. Stop stitching ¼" from the corner. Backstitch and remove the quilt from the sewing machine.

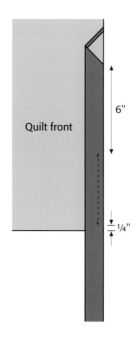

Quilt front

6"

¼"

4. Turn the quilt to prepare to sew the next edge. Fold the binding straight up, creating a 45°-angle fold.

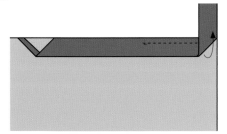

5. Fold the binding down, having the fold even with the top edge of the quilt and the raw edge aligned with the side of the quilt. Beginning at the edge, stitch the binding to the quilt, stopping ¼" from the next corner. Backstitch and remove the quilt from the machine. Continue the folding and stitching process for the remaining corners.

6. When you reach the beginning of the binding, cut the end 1" longer than needed and tuck the end inside the beginning. Stitch the rest of the binding.

7. Fold the binding to the back of the quilt over the raw edges of the quilt "sandwich," covering the machine stitching. Slipstitch the binding in place.

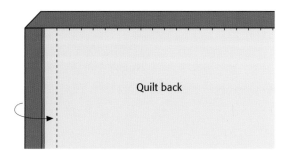

Quilt back

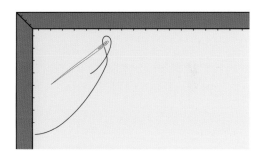

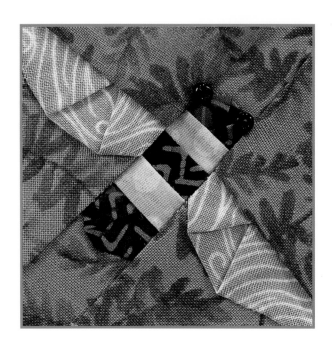

Bee I

Finished Size: 2" x 2"
Joining Sequence:
A + B = AB
AB + C = ABC
ABC + D = Bee I

Detail:
Stitch 3mm beads to head for eyes.

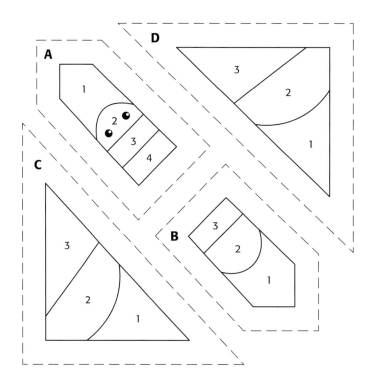

Bee II

Finished Size: 3" x 3"

Joining Sequence:

A + B = AB

AB + C = ABC

ABC + D = Bee II

Detail:

Stitch 4mm beads to head for eyes.

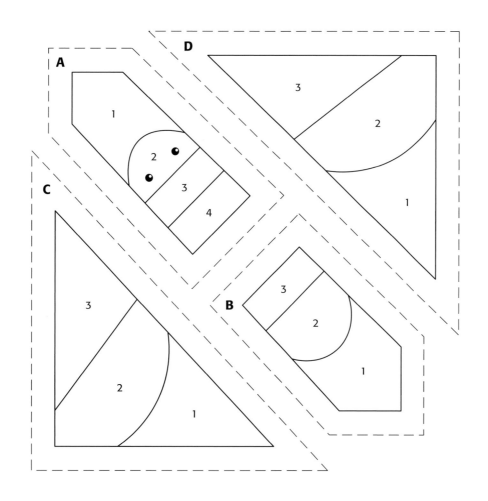

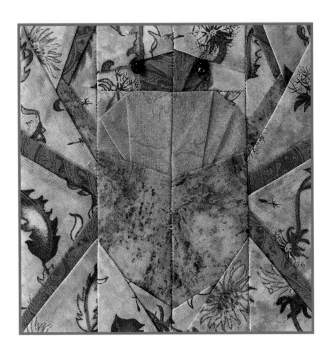

Beetle

Finished Size: 4" x 4"

Joining Sequence:

A + B = AB

D + E = DE

AB + DE = ABDE

ABDE + C = ABCDE

ABCDE + F = Beetle

Detail:

Stitch 4mm beads to head for eyes.

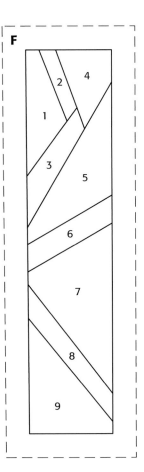

Bird in Nest

Finished Size: 4" x 4"

Joining Sequence:

A + B = AB

AB + C = ABC

ABC + D = ABCD

ABCD + E = ABCDE

ABCDE + F = Bird in Nest

Detail:

Stitch 3mm bead to head for eye.

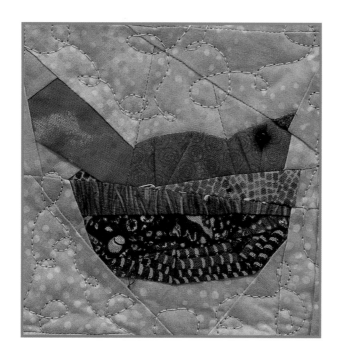

Bird in Nest

Butterfly I

Finished Size: 4" x 4"
Joining Sequence:
A + B = AB
AB + C = Butterfly I

Detail:
Stitch 3mm beads to head for eyes.

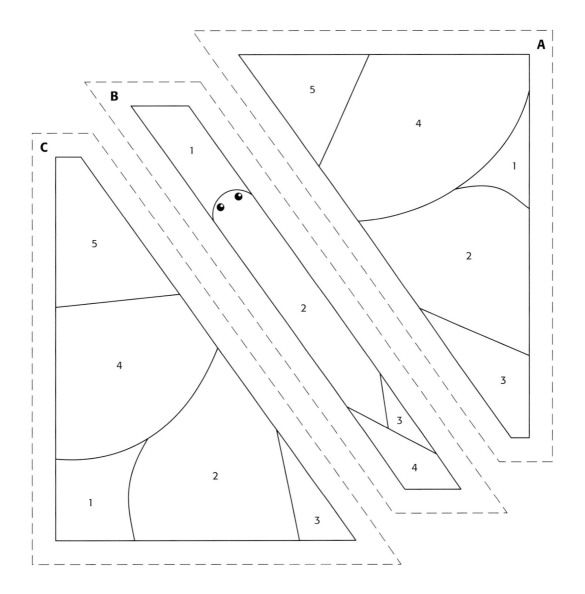

Butterfly II

Finished Size: 4" x 4"
Joining Sequence:
A + B = AB
AB + C = Butterfly II

Detail:
Stitch 3mm bead to head for eye.

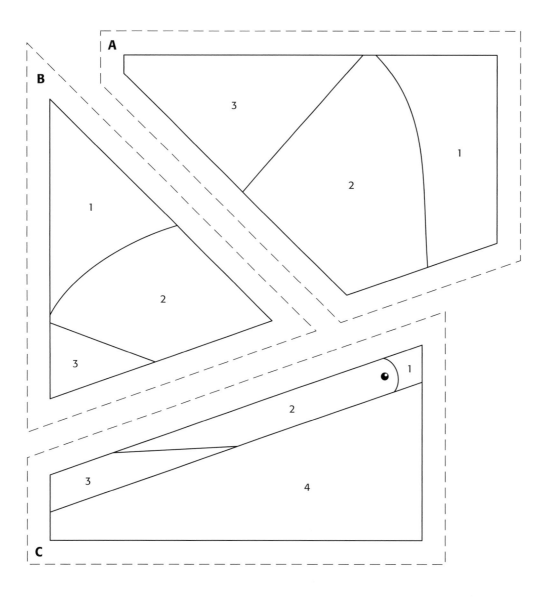

Caterpillar

Finished Size: 2" x 4"
Joining Sequence:
A + B = Caterpillar

Detail:
Stitch 4mm bead to head for eye.

Cattail

Finished Size: 4" x 8"
Joining Sequence:
A + B = AB
AB + C = Cattail

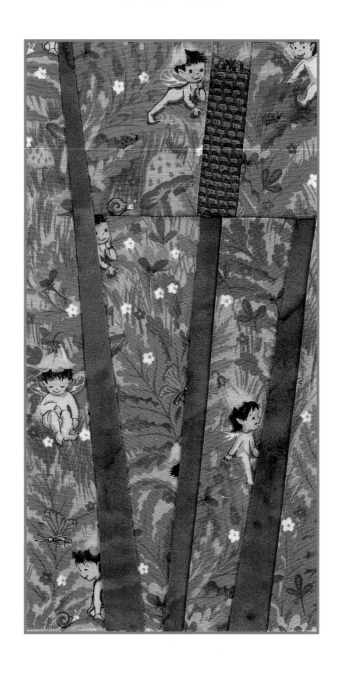

Cornflower

Finished Size: 4" x 6"
Joining Sequence:
A + B = AB
AB + C = ABC
ABC + D = ABCD
ABCD + E = Cornflower

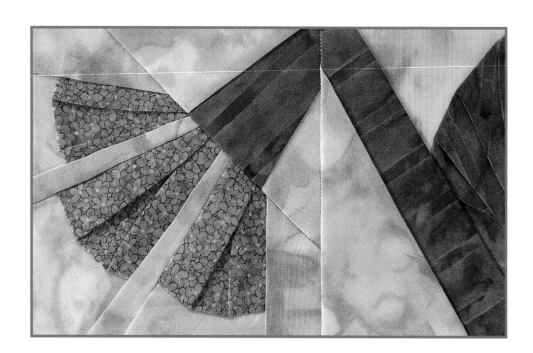

Cornflower

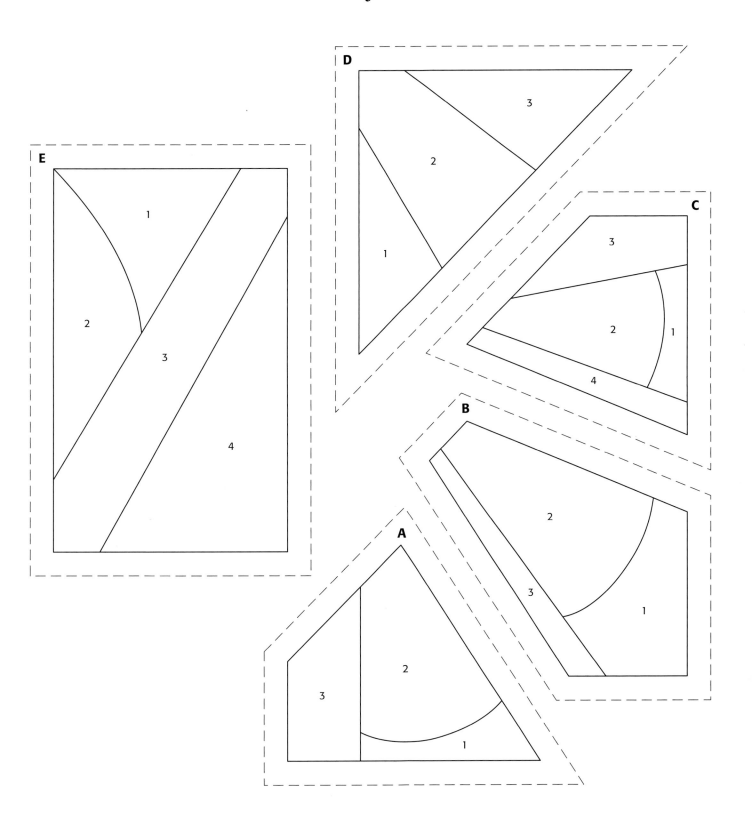

Crocus

Finished Size: 4" x 4"
Joining Sequence:
A + B = AB
AB + C = ABC
ABC + D = Crocus

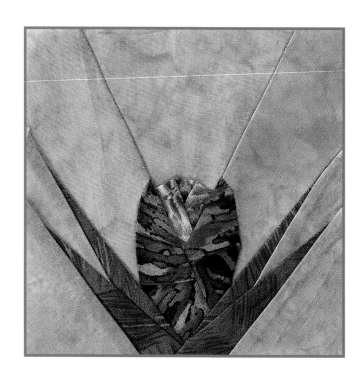

Crocus

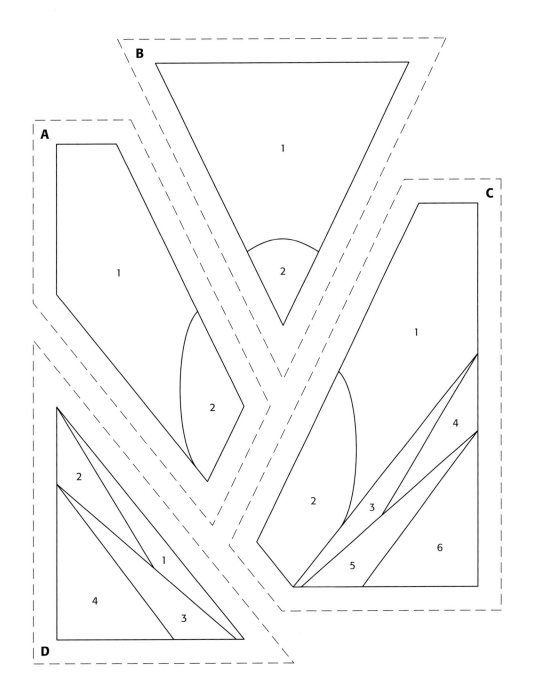

Daffodil

Finished Size: 4" x 8"
Joining Sequence:
A + B = AB
AB + C = ABC
ABC + D = ABCD
E + F = EF
ABCD + EF = Daffodil

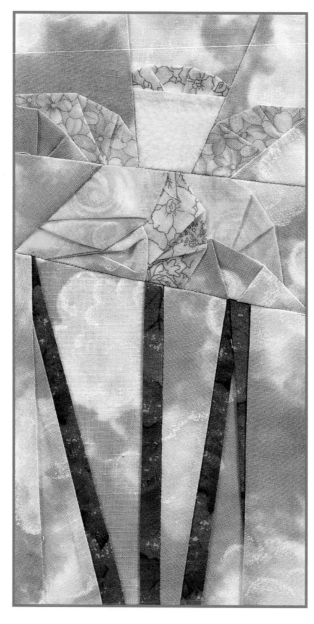

Daffodil

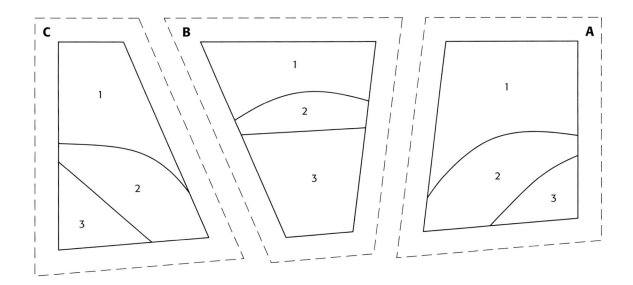

Daffodil

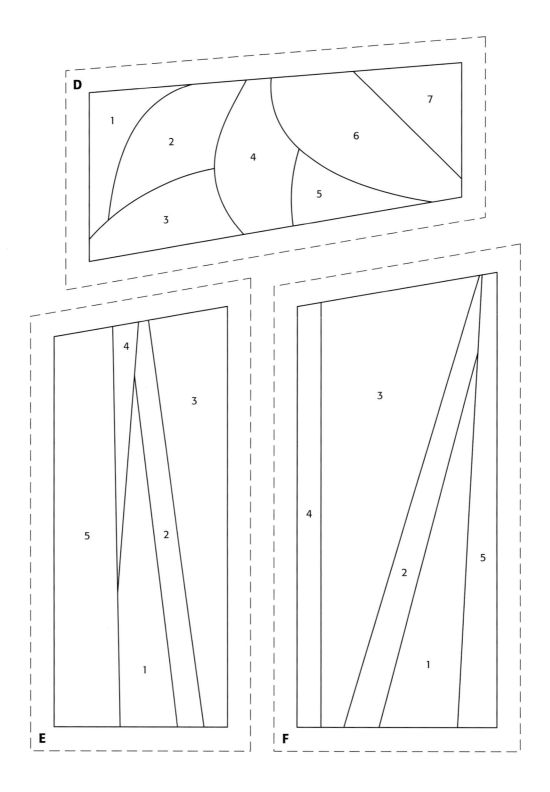

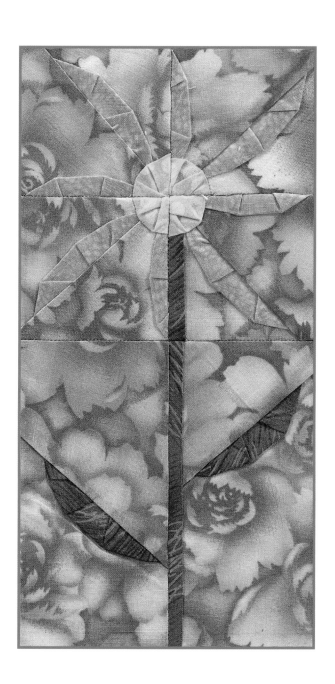

Daisy I

Finished Size: 4" x 8"

Joining Sequence:

Refer to the illustration below to join 3 A units and 1 B unit to make the AAAB unit.

C + D = CD

AAAB + CD = Daisy I

Daisy I

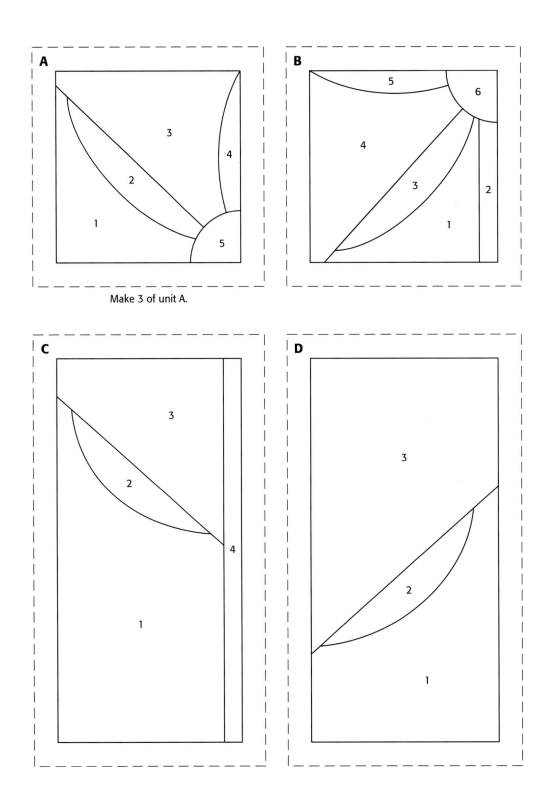

Make 3 of unit A.

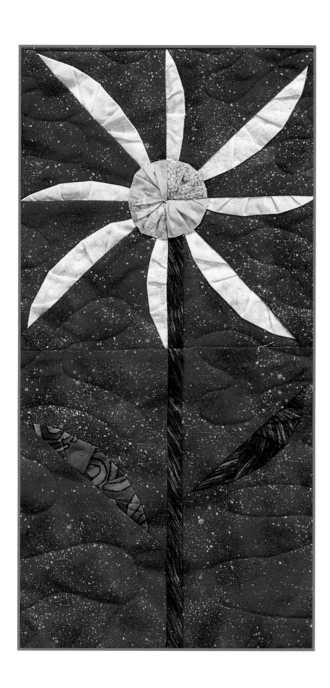

Daisy II

Finished Size: 8" x 16"
Joining Sequence:

Refer to the illustration below to join 3 A units and 1 B unit to make the AAAB unit.

C + D = CD

AAAB + CD = Daisy II

Daisy II

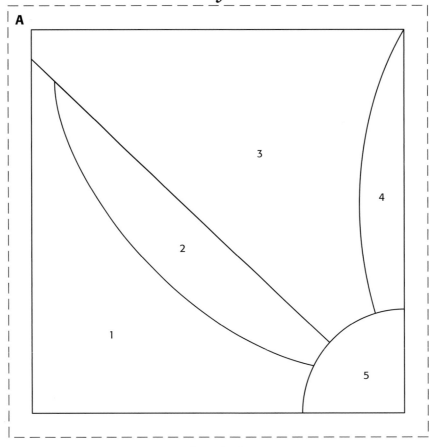

Make 3 of unit A.

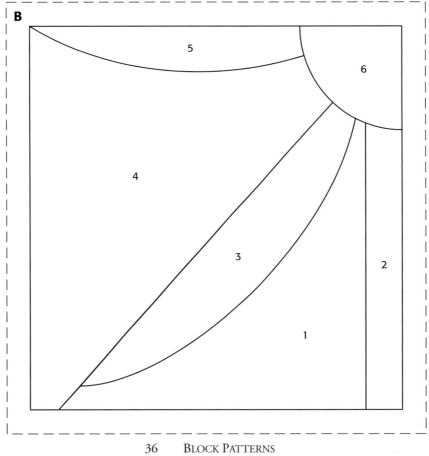

Daisy II

Daisy II

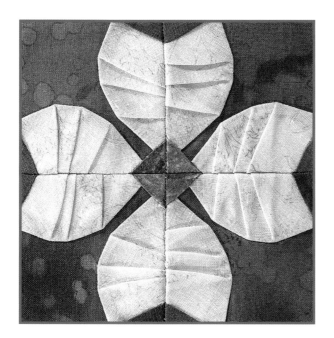

Dogwood Blossom

Finished Size: 4" x 4"
Joining Sequence:
Refer to illustration below.

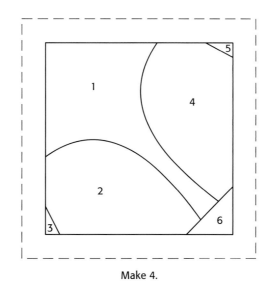

Make 4.

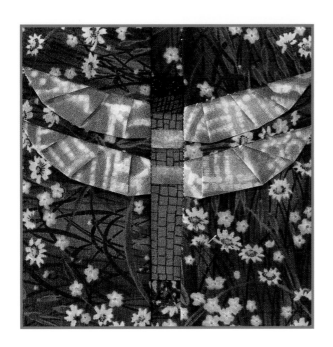

Dragonfly I

Finished Size: 2" x 2"
Joining Sequence:
A + B = AB
AB + C = Dragonfly I

Detail:
Stitch seed beads to head for eyes.

Dragonfly II

Finished Size: 4" x 4"
Joining Sequence:

A + B = AB

AB + C = Dragonfly II

Detail:
Stitch 4mm beads to head for eyes.

Flowerpot

Finished Size: 4" x 4"

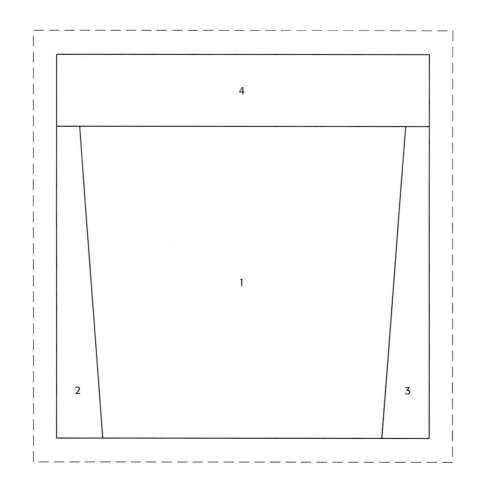

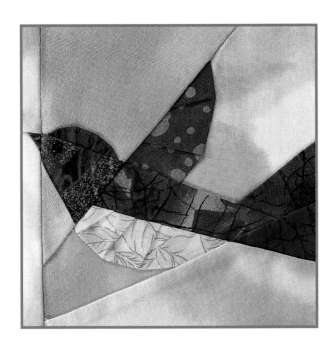

Flying Bird

Finished Size: 4" x 4"
Joining Sequence:
A + B = AB
AB + C = ABC
ABC + D = Flying Bird

Detail:
Stitch 3mm bead to head for eye.

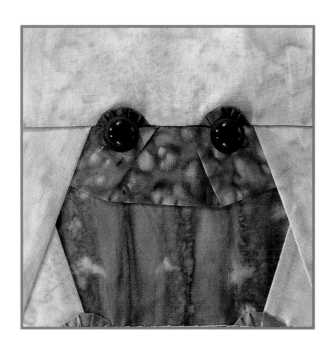

Frog

Finished Size: 4" x 4"

Joining Sequence:

A + B = Frog

Detail:

Stitch ½"-diameter buttons to head for eyes.

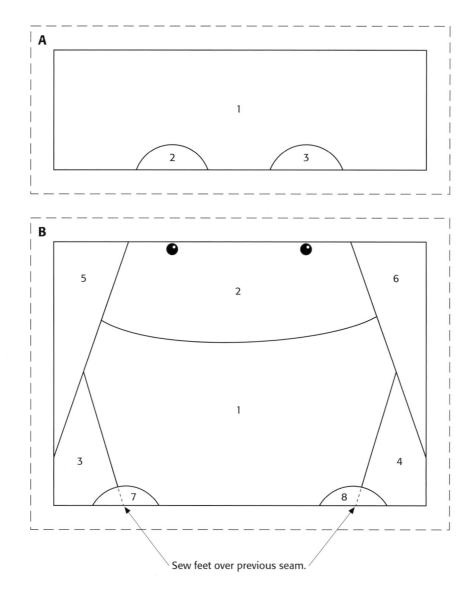

Sew feet over previous seam.

Grasshopper

Finished Size: 4" x 8"

Joining Sequence:

A + B = AB

C + D = CD

AB + CD = Grasshopper

Detail:

Stitch ¼"-diameter button to head for eye.

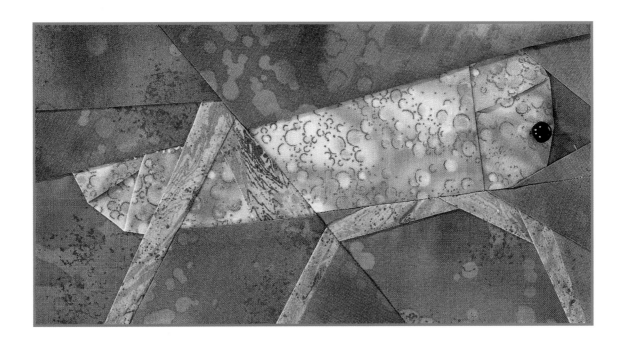

Grasshopper

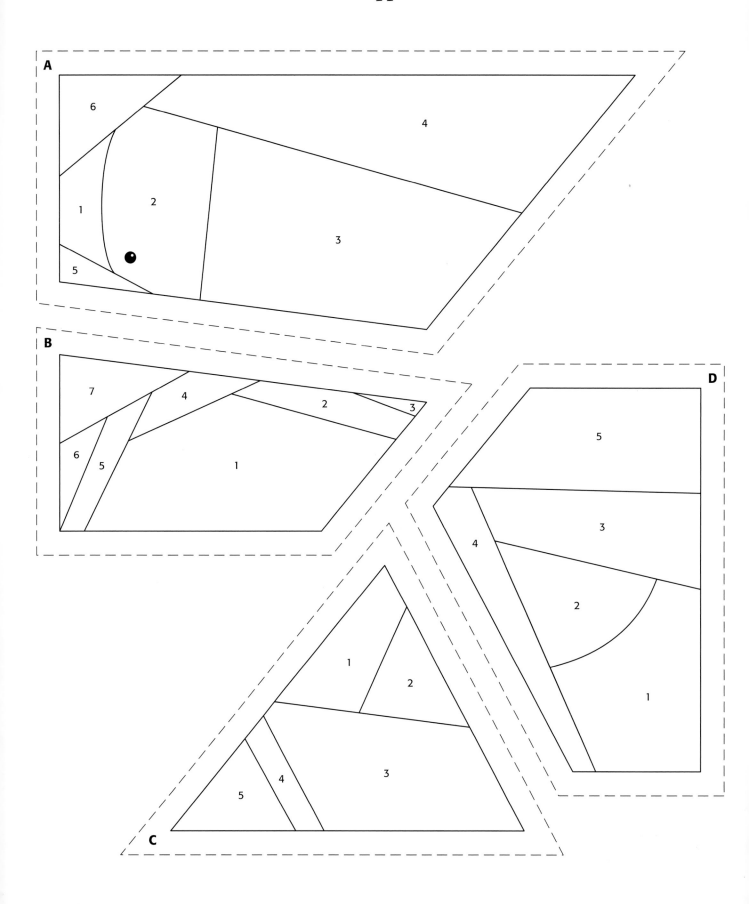

Hummingbird

Finished Size: 4" x 4"

Joining Sequence:

A + B = AB

AB + C = ABC

E + F = EF

D + EF = DEF

ABC + DEF = ABCDEF

ABCDEF + G = Hummingbird

Detail:

Stitch 4mm bead to head for eye.

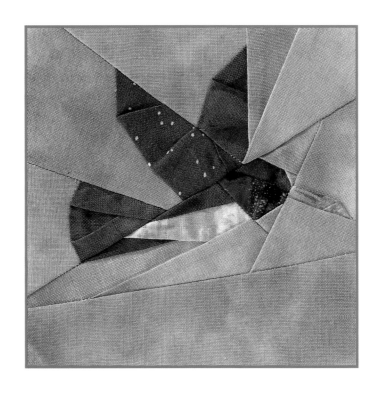

Hummingbird

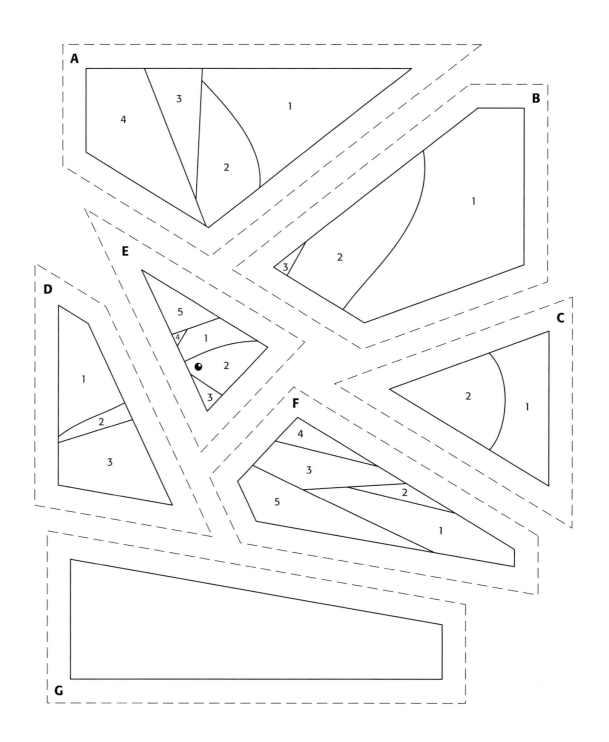

Iris

Finished Size: 4" x 8"

Joining Sequence:

A + B = AB

C + D = CD

AB + E = ABE

ABE + CD = ABCDE

F + G = FG

ABCDE + FG = Iris

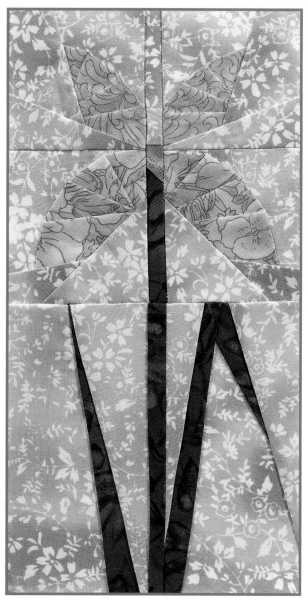

Iris

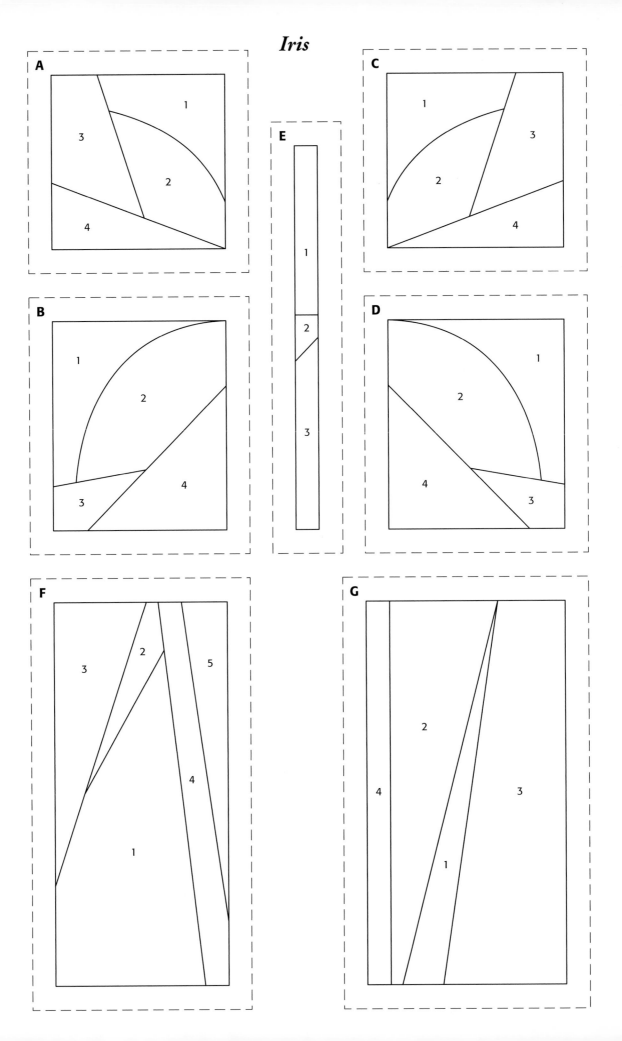

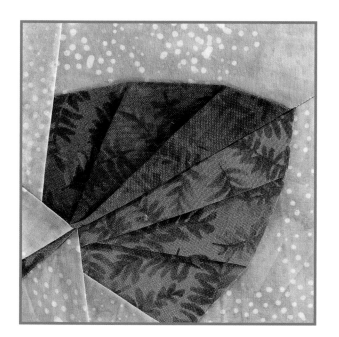

Ivy I

Finished Size: 2" x 2"
Joining Sequence:
A + B = Ivy I

Ivy II

Finished Size: 4" x 4"
Joining Sequence:
A + B = Ivy II

Ladybug I

Finished Size: 2" x 2"
Joining Sequence:
A + B = AB
AB + C = ABC
ABC + D = Ladybug

Details:
Stitch 3mm beads to head for eyes.
Stitch ³⁄₁₆"-diameter buttons to body
for spots (optional).

Ladybug II

Finished Size: 4" x 4"
Joining Sequence:
A + B = AB
AB + C = ABC
ABC + D = Ladybug II

Details:
Stitch 4mm beads to head for eyes.
Stitch ¼"-diameter buttons to body for spots (optional).

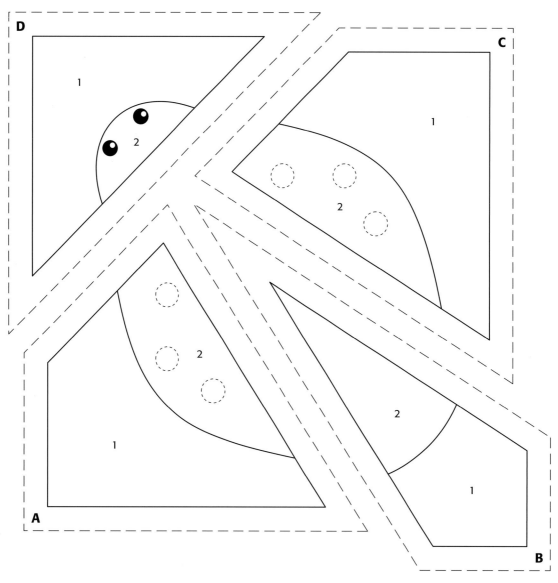

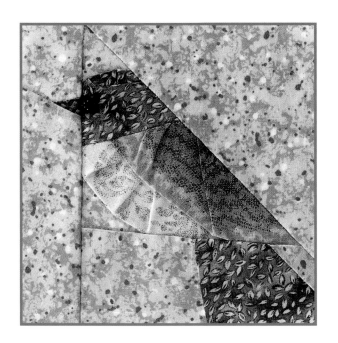

Perched Bird

Finished Size: 4" x 4"
Joining Sequence:
A + B = AB
AB + C = ABC
ABC + D = ABCD
ABCD + E = Perched Bird

Detail:
Stitch 4mm bead to head for eye.

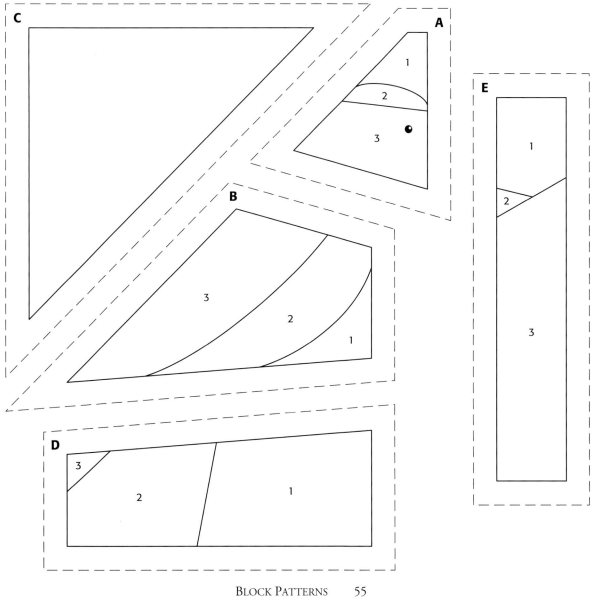

Picket Fence

Finished Size: 8" x 7"
Joining Sequence: See page 12.

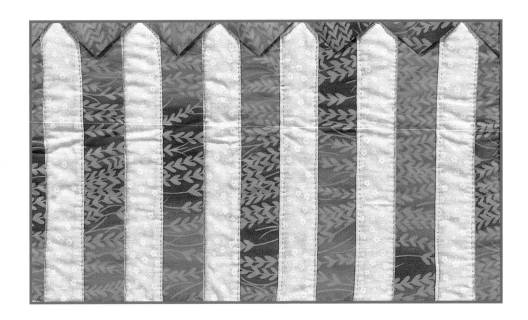

Picket Fence

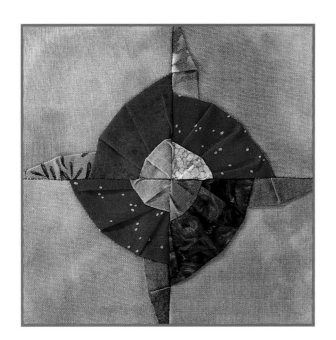

Rose I

Finished Size: 4" x 4"
Joining Sequence:
Refer to illustration below.

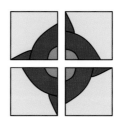 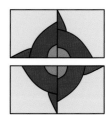

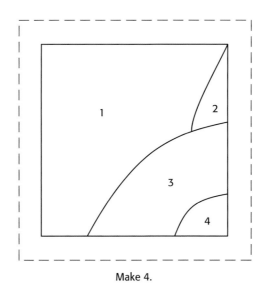

Make 4.

Rose II

Finished Size: 8" x 8"
Joining Sequence:
Refer to illustration on page 58.

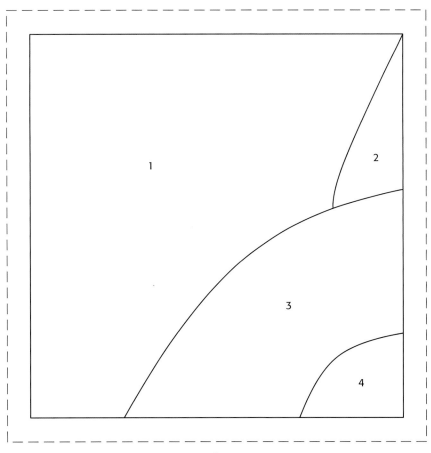

Make 4.

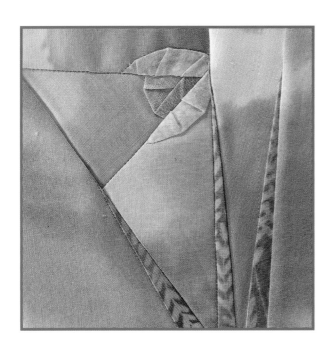

Finished Size: 4" x 4"
Joining Sequence:
A + B = AB
AB + C = ABC
ABC + D = ABCD
ABCD + E = Snowdrop

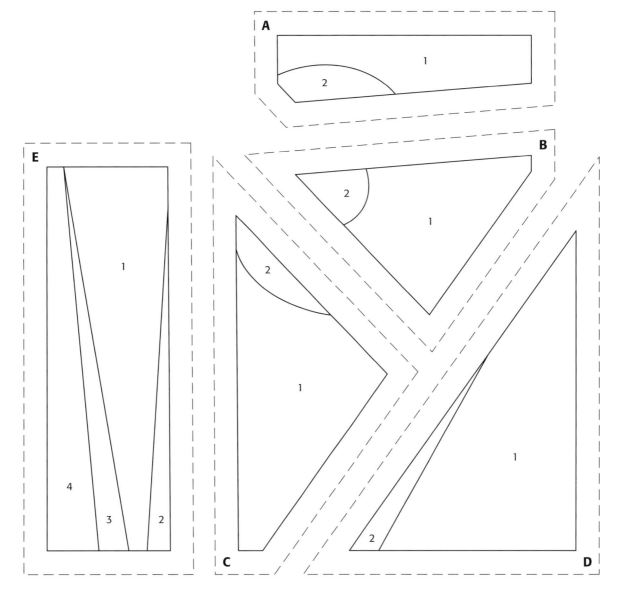

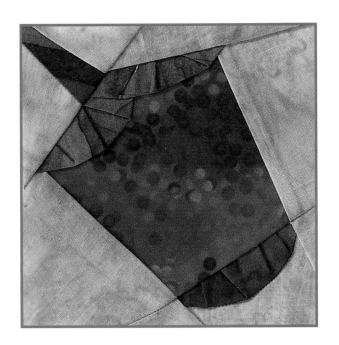

Strawberry

Finished Size: 4" x 4"
Joining Sequence:
A + B = AB
AB + C = Strawberry

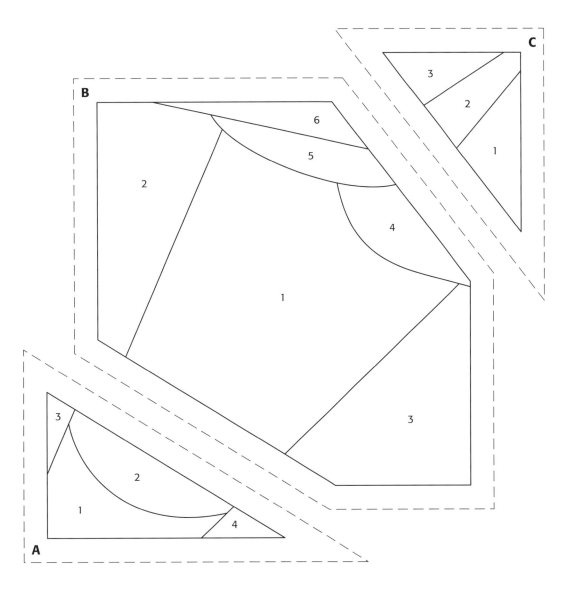

Tulip

Finished Size: 4" x 8"
Joining Sequence:
A + B = AB
C + D = CD
AB + CD = Tulip

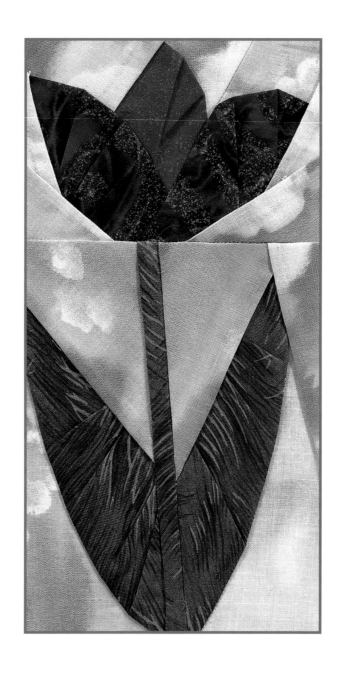

Tulip

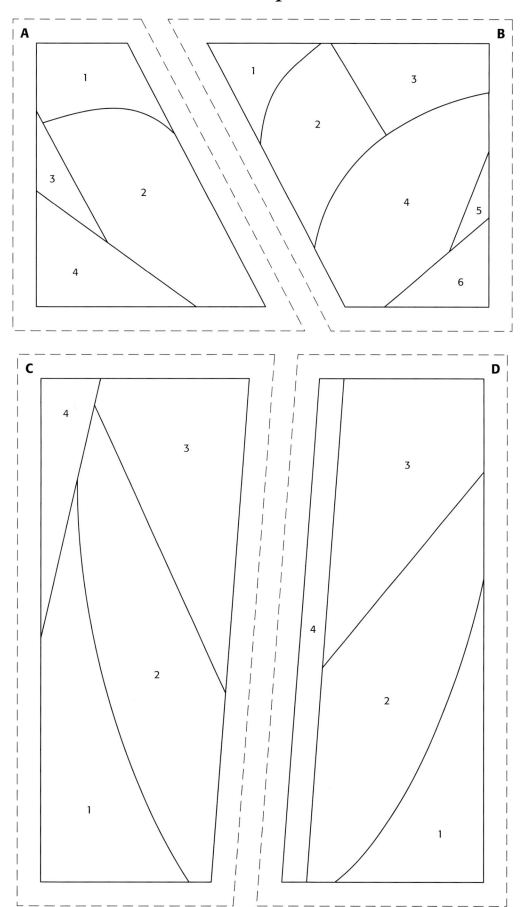

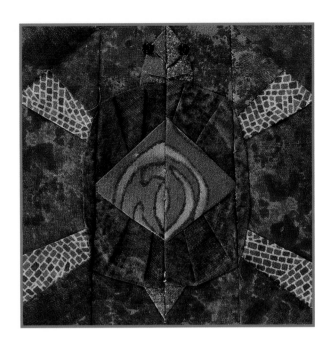

Turtle

Finished Size: 4" x 4"
Joining Sequence:
A + C = AC
B + D = BD
AC + BD = ABCD
ABCD + E = ABCDE
ABCDE + F = Turtle

Detail:
Stitch ¼"-diameter buttons to head for eyes.

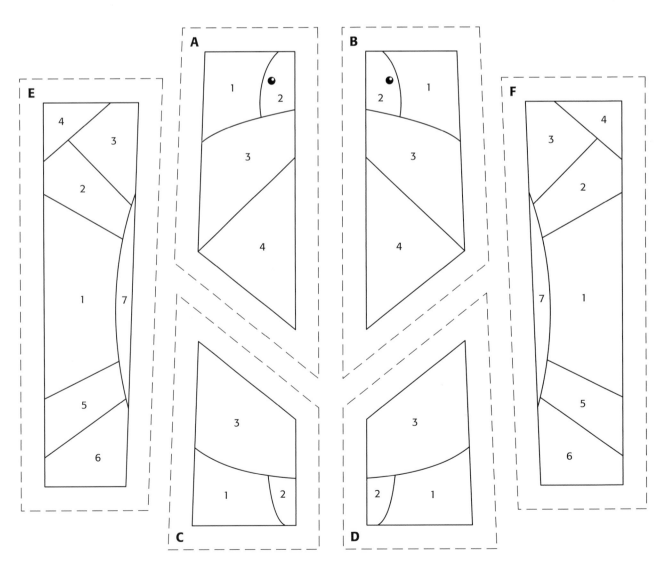

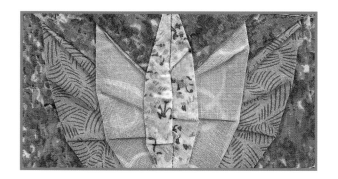

Water Lily Flower

Finished Size: 2" x 4"
Joining Sequence:
A + B = Water Lily Flower

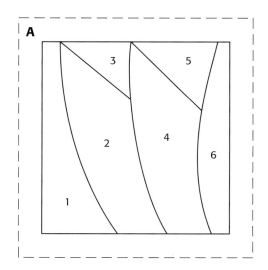

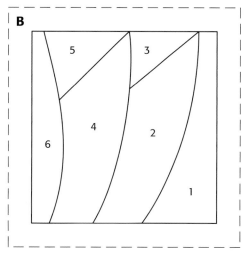

A

3
5
2
4
6
1

B

5
3
6
4
2
1

Water Lily Leaf

Finished Size: 2" x 4"
Joining Sequence:
A + B = Water Lily Leaf

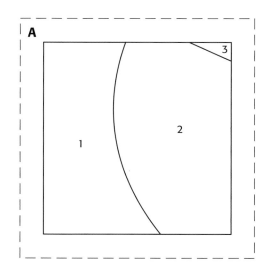

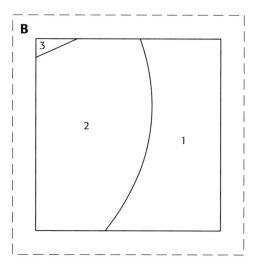

A

3
1
2

B

3
2
1

THE QUILTS

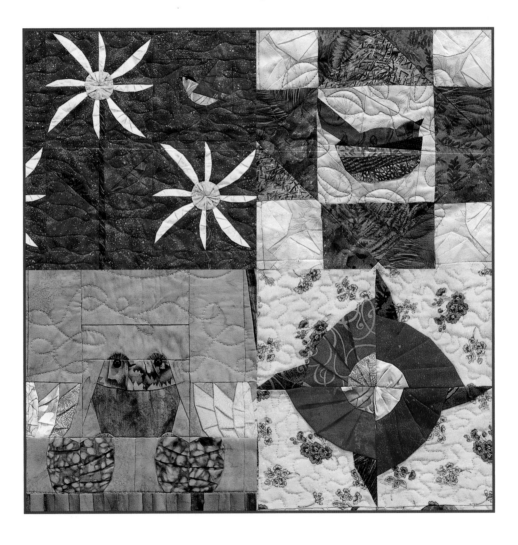

View from My Window

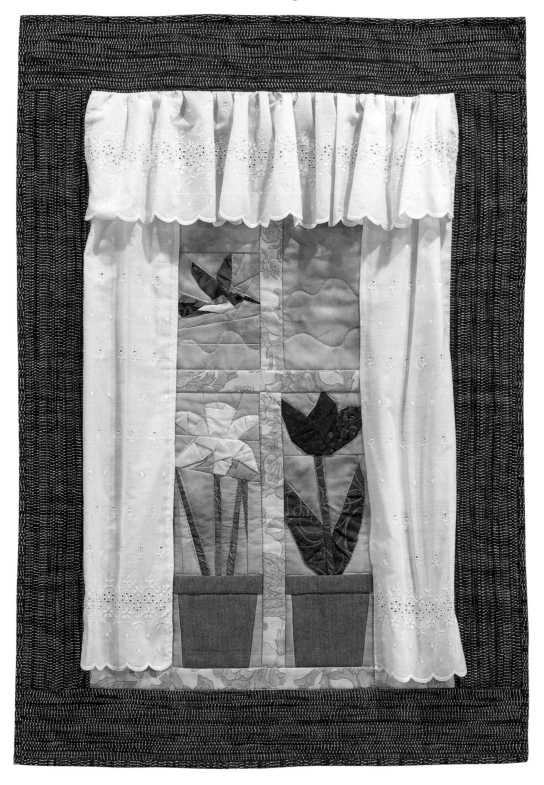

VIEW FROM MY WINDOW *by Jodie Davis, 2000, Canton, Georgia, 21½" x 32"*

Materials

42"-wide fabric

- ½ yd. blue print for block backgrounds and windowpane pieces
- ⅛ yd. (or scrap) of terra-cotta solid for flowerpots
- ⅛ yd. *each* (or scraps) of 2 or more assorted yellow prints for daffodil
- ⅛ yd. *each* (or scraps) of 2 or more assorted red prints for tulip and hummingbird head
- ⅛ yd. *each* (or scraps) of 2 or more assorted green prints for stems, leaves, and hummingbird wings and body
- Scrap of white print for hummingbird breast
- Scrap of brown print for hummingbird bill
- ½ yd. beige print for window mullions, sill, and framework
- 1⅜ yds. white eyelet with one finished edge
- ½ yd. dark brown print for border and binding
- 26" x 36" piece of batting
- ⅞ yd. fabric for backing
- One 4mm black bead for hummingbird eye

Cutting

From the blue print, cut:
- 1 rectangle, 7½" x 4½", for blank glass pane
- 1 strip, 12½" x 4½", for hummingbird glass pane
- 1 strip, 1½" x 4½", for hummingbird glass pane

From the beige print, cut:
- 2 strips, each 1½" x 12½", for vertical window mullions
- 2 strips, 1½" x 9½", for horizontal window mullion and windowsill
- 2 strips, each 3¾" x 26½", for window framework

From the white eyelet, cut:
- 2 strips, each 6½" x 26¼", for curtains, cutting one short edge along the finished edge of the fabric
- 1 strip, 6¼" x 32", for valance, cutting one long edge along the finished edge of the fabric

From the dark brown fabric, cut:
- 2 strips, each 3½" x 26½", for side borders
- 2 strips, each 3½" x 22", for top and bottom borders
- 3 strips, each 2½" x 42", for binding

From the backing fabric, cut:
- 1 piece, 26" x 36"

Quilt Top Assembly

1. Refer to "Transferring the Patterns" on page 7 and the chart below to prepare the following foundations.

Block Name	Number to Trace
Daffodil (page 30)	1
Flowerpot (page 42)	2
Hummingbird (page 47)	1
Tulip (page 62)	1

2. To piece each block, refer to "Basic Paper Piecing" on pages 8–10 and "Paper Piecing Curved Seams" on pages 10–12. Follow the "Joining Sequence" instructions that appear on the same page as the patterns to assemble blocks with subunits.

3. Stitch the 4½" x 7½" blue print rectangle to the top of the Hummingbird block. Stitch the 1½" x 4½" blue print strip to the bottom of the Hummingbird block. Press the seam allowances away from the Hummingbird block.

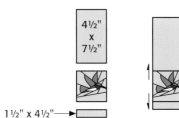

4. To make the upper window section, stitch a vertical mullion strip to the right side of the Hummingbird pane. Stitch the 4½" x 12½" blank pane to the right side of the Hummingbird/mullion unit. Press the seam allowances toward the million strip.

5. Stitch a Flowerpot block to the lower edges of the Daffodil and Tulip blocks. Press the seam allowances open.

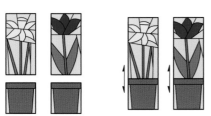

6. To make the lower window section, stitch a vertical mullion strip to the right side of the Daffodil block. Stitch the Tulip block to the Daffodil/mullion unit. Press the seam allowances toward the mullion strip.

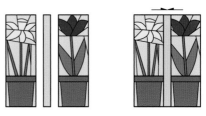

7. Stitch the horizontal mullion strip to the upper window section. Sew the windowsill strip to the lower window section. Stitch the lower window unit to the upper window unit. Press the seam allowances toward the mullion and windowsill strips.

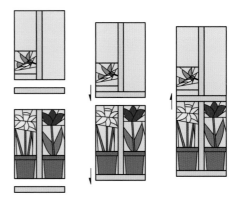

8. Stitch the framework strips to the quilt sides. Press the seam allowances toward the framework strips.

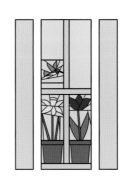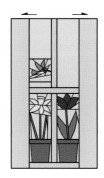

9. Remove the remaining paper foundations.

10. Press one long edge of each curtain piece under ¼" and topstitch in place. Repeat for the valance's short ends. Baste ¼" from the valance's long unfinished edge.

11. Align the unfinished short ends of the curtain pieces with the quilt upper edge and the unfinished long, outer edges with the sides of the framework.

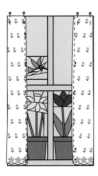

12. Align the valance-basted edge with the quilt upper edge. Draw up the basting stitches to gather the upper edge so the ends align with the curtain outer edges. Adjust the gathers evenly and pin in place.

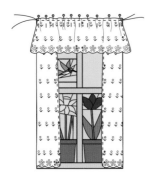

13. Stitch the side borders to the quilt sides including the edges of the curtains in the seam. Press the seam allowances toward the borders. Stitch the top and bottom borders to the quilt. Remove the basting stitches from the valance. Press the seam allowances toward the borders.

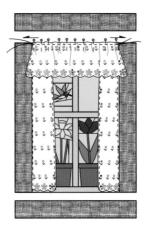
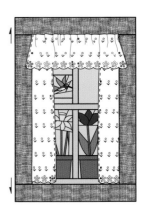

14. Following the instructions in "Preparing for Quilting" on page 13, layer the quilt top with batting and backing.

15. Quilt as desired.

16. Refer to "Making and Applying Binding" on pages 14–15 to make the binding and bind the quilt edges.

17. Stitch the bead to the hummingbird head as indicated in the block pattern on page 48.

Garden Sampler

GARDEN SAMPLER *by Jodie Davis, 2000, Canton, Georgia, 36" x 32".*

Materials

42"-wide fabric

- 2½ yds. of blue print for block backgrounds, bee block filler pieces, and borders
- ¼ yd. *each* (or scraps) of 6 assorted red prints for strawberries, ladybugs, and bird
- ⅛ yd. *each* (or scraps) of 9 assorted browns for beetle, grasshopper, bird nest, butterfly bodies, ladybug bodies, and bee wings
- Scraps of 2 assorted black prints for bee bodies and ladybug heads
- ⅛ yd. (or scrap) of bright pink for daisy petals
- ⅛ yd. *each* (or scraps) of 7 assorted yellow prints for caterpillars, daisy centers, butterfly wings, bee bodies, daffodil, and crocuses
- ⅛ yd. *each* (or scraps) of 8 total assorted blue prints and purple prints for iris, crocuses, and butterfly wings
- ⅛ yd. (or scrap) of white solid for crocuses and snowdrops
- 1 yd. *total* of assorted green prints for strawberry caps, caterpillars, stems, and leaves
- 36" x 40" piece of batting
- 1 yd. of fabric for backing
- ⅜ yd. of green print for binding
- Twelve 3mm black beads for ladybug, bee, butterfly, and bird eyes
- Four 4mm black beads for caterpillar and beetle eyes
- Three ¼"-diameter black buttons for grasshopper and turtle eyes

Cutting

From the blue print, cut:

1 strip, 1½" x 42". Crosscut to make:
 4 strips, each 1½" x 2½", for bee block side pieces
 4 strips, each 1½" x 4½", for bee block top and bottom pieces

2 strips, each 4½" x 24½", for side borders
2 strips, each 4½" x 36½", for top and bottom borders

From the backing fabric, cut:

1 piece, 36" x 40"

From the binding fabric, cut:

4 strips, each 2½" x 42"

Quilt Top Assembly

1. Refer to "Transferring the Patterns" on page 7 and the chart below to prepare the foundations.

Block Name	Number to Trace
Bee I (page 16)	2
Beetle (page 18)	1
Bird in Nest (page 19)	1
Butterfly I (page 21)	1
Butterfly II (page 22)	1
Caterpillar (page 23)	2
Crocus (page 28)	7
Daffodil (page 30)	1
Daisy I, head only (page 33)	2
Grasshopper (page 45)	1
Iris (page 49)	1
Ivy I (page 51)	14
Ivy II (page 52)	7
Ladybug I (page 53)	2 (mirror image 1)
Snowdrop (page 60)	2 (mirror image 1)
Strawberry (page 61)	6 (mirror image 3)
Turtle (page 64)	1

2. To piece each block, refer to "Basic Paper Piecing" on pages 8–10 and "Paper Piecing Curved Seams" on pages 10–12. Follow the "Joining Sequence" instructions that appear on the same page as the patterns to assemble blocks with subunits.

3. Stitch the 1½" x 2½" strips to the sides of the Bee I blocks. Press the seam allowances toward the strips. Stitch the 1½" x 4½" strips to the top and bottom of the Bee I blocks. Press the seam allowances toward the strips.

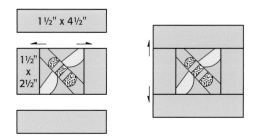

4. Stitch the blocks for each row into units as shown. Stitch the units together into rows.

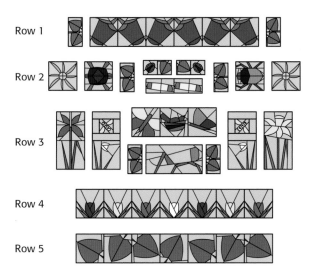

5. Stitch the rows together.

6. Stitch the side border strips to the quilt sides. Remove the paper from the stitched seam allowances. Press the seam allowances toward the border strips. Stitch the top and bottom border strips to the top and bottom edges of the quilt. Remove the paper from the stitched seam allowances. Press the seam allowances toward the border strips.

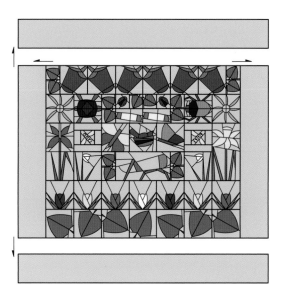

7. Remove the remaining paper foundations.

8. Following the instructions in "Preparing for Quilting" on page 13, layer the quilt top with batting and backing.

9. Quilt as desired.

10. Refer to "Making and Applying Binding" on pages 14–15 to make the binding and bind the quilt edges.

11. Stitch the beads and buttons to the appropriate blocks as indicated in the block patterns on pages 16–64.

Loving Life in the Pond

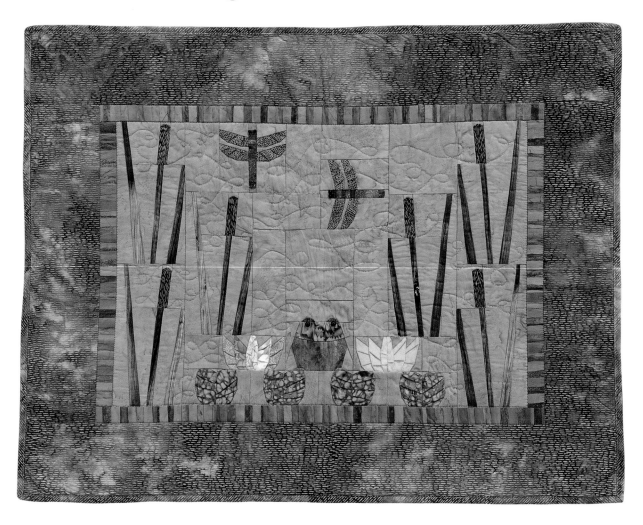

LOVING LIFE IN THE POND *by Jodie Davis, 2000, Canton, Georgia, 34" x 26".*

Materials

42"-wide fabric

- 1 yd. light green print for block backgrounds and filler pieces
- ⅛ yd. *each* (or scraps) of 3 assorted medium green prints for frog head, frog body, and lily leaves
- ¼ yd. variegated light-to-dark green print for cattail leaves
- ⅛ yd. *each* (or scraps) of 3 assorted brown prints for cattail spikes, dragonfly bodies, and dragonfly wings
- Scraps of blue print for dragonfly heads
- Scraps of red print for dragonfly bodies
- Scraps of 3 assorted yellow prints for lily flower
- Scraps of 3 assorted pink prints for lily flower
- ¼ yd. green stripe for inner border
- 1 yd. variegated green-and-pink print for outer border and bias binding
- 30" x 38" piece of batting
- 1 yd. fabric for backing
- Four 4mm black beads for dragonfly eyes
- Two ½"-diameter buttons for frog eyes

Cutting

From the light green print, cut:

2 squares, each 2½" x 2½", for filler pieces
2 rectangles, each 2½" x 4½", for filler pieces
2 strips, each 2½" x 6½", for filler pieces
2 squares, each 4½" x 4½", for filler pieces
1 strip, 2½" x 8½", for filler piece

From the green stripe, cut:

2 strips, each 1½" x 16½", for inner side borders
2 strips, each 1½" x 26½", for inner top and bottom borders

From the variegated green-and-pink fabric, cut:

2 strips, each 4½" x 18½", for outer side borders
2 strips, each 4½" x 34½", for outer top and bottom borders

From the backing fabric, cut:

1 piece, 30" x 38"

Quilt Top Assembly

1. Refer to "Transferring the Patterns" on page 7 and the chart below to prepare the foundations.

Block Name	Number to Trace
Cattail (page 24)	6 (mirror-image 3)
Dragonfly II (page 41)	2
Frog (page 44)	1
Water Lily Flower (page 65)	2
Water Lily Leaf (page 65)	4

2. To piece each block, refer to "Basic Paper Piecing" on pages 8–10 and "Paper Piecing Curved Seams" on pages 10–12. Follow the "Joining Sequence" instructions that appear on the same page as the patterns to assemble blocks with subunits. Do not stitch the yellow water lily flower together.

3. Stitch the filler pieces to the blocks as shown. Stitch the remaining 2½" x 6½" filler piece to the appropriate Dragonfly II block as shown. Press the seam allowances toward the filler strips.

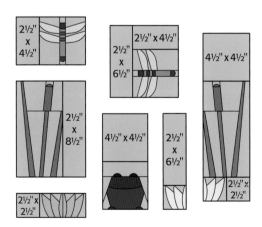

4. Stitch the blocks together into sections as shown.

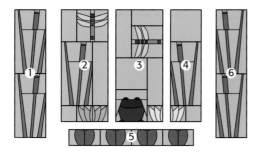

5. Sew Sections 2, 3, and 4 together first. Stitch section 5 to the bottom of Section 2/3/4. Stitch Sections 1 and 6 to the sides of Section 2/3/4/5.

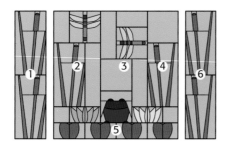

6. Stitch the inner side border strips to the quilt sides. Remove the paper from the stitched seam allowances. Press the seam allowances open. Stitch the inner top and bottom border strips to the top and bottom edges of the quilt. Remove the paper from the stitched seam allowances. Press the seam allowances open.

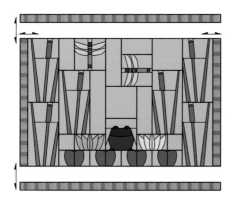

7. Remove the remaining paper foundations.

8. Stitch the outer side border strips to the quilt sides. Press the seam allowances toward the outer border strips. Stitch the outer top and bottom border strips to the top and bottom edges of the quilt. Press the seam allowances toward the outer border strips.

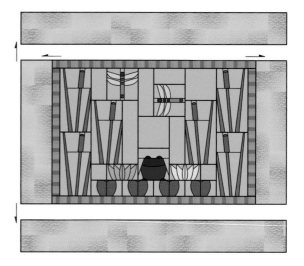

9. Following the instructions in "Preparing for Quilting" on page 13, layer the quilt top with batting and backing.

10. Quilt as desired.

11. Refer to "Making and Applying Binding" on pages 14–15 to make 4 yards of bias binding from the remaining variegated green-and-pink fabric and bind the quilt edges.

12. Stitch the beads to the dragonfly blocks and the buttons to the Frog block as indicated in the block patterns on pages 41 and 44.

Nesting in the Dogwoods

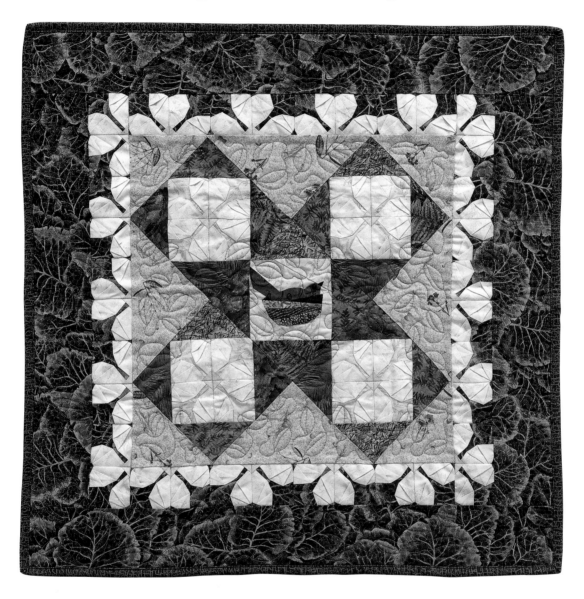

NESTING IN THE DOGWOODS *by Jodie Davis, 2000, Marietta, Georgia, 26" x 26". Pieced by Tammy Silvers.*

Materials

42"-wide fabric

- ¾ yd. cream print for center block backgrounds
- 1 yd. white solid or print for dogwood petals
- ¼ yd. yellow solid or print for dogwood blossom centers
- Scrap of blue print for bird
- Scraps of 4 assorted brown prints for bird nest
- ⅛ yd. *each* (or scraps) of 6 assorted green prints for block corner triangles
- ½ yd. beige print for corner and setting triangles
- ⅜ yd. dark green print for inner border block backgrounds and outer border
- 30" x 30" square of batting
- 1 yd. fabric for backing
- ¼ yd. dark green print for binding
- 3mm black bead for bird eye

Cutting

From the 6 assorted green fabrics, cut:

10 squares, each 3¾" x 3¾". Cut each square in half diagonally to make 20 block corner triangles (A).

From the beige print, cut:

2 squares, each 5" x 5". Cut each square in half diagonally to make 4 corner triangles (B).

1 square, 9¼" x 9¼". Cut in half twice diagonally to make 4 setting triangles (C).

From the green print for the borders, cut:

2 strips, each 3½" x 20½", for outer side borders

2 strips, each 3½" x 26½", for outer top and bottom borders

From the backing fabric, cut:

1 piece, 30" x 30"

From the binding fabric, cut:

3 strips, each 2½" x 42"

Quilt Top Assembly

1. Refer to "Transferring the Patterns" on page 7 and the chart below to prepare the following foundations.

Block Name	Number to Trace
Bird in Nest (page 19)	1
Dogwood Blossom (page 39)	52 subunits

2. To piece the Bird in a Nest block, refer to "Basic Paper Piecing" on pages 8–10 and "Paper Piecing Curved Seams" on pages 10–12. Follow the "Joining Sequence" instructions that appear on the same page as the pattern to assemble the blocks.

3. To piece the Dogwood Blossom subunits, refer to "Basic Paper Piecing" on pages 8–10 and "Paper Piecing Curved Seams" on pages 10–12 to make 16 subunits using cream print for the background and 36 subunits using dark green print for the background. Follow the illustration that appears on the same page as the pattern to assemble the cream background subunits into 4 whole flowers for the center blocks. Join the green background units into pairs to make 18 half-flowers for the inner border blocks.

Make 4.

Make 18.

4. Stitch an A triangle to each side of a Dogwood Blossom block and to each side of the Bird in Nest block, beginning with the sides, then the top and bottom. Press the seam allowances toward the triangles.

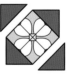

Make 4.

Make 1.

5. Stitch the blocks, setting triangles, and corner triangles into 3 rows as shown. Add the remaining corner triangles. Press the seam allowances toward the setting and corner triangles.

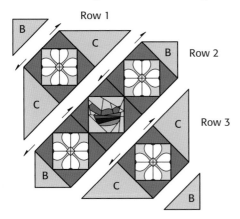

6. To assemble the inner border strips, stitch 4 half-flower units together to make the inner top and bottom border strips. Make 2. Stitch 5 half-flower units together to make the inner side border strips. Make 2.

Inner top and bottom borders
Make 2.

Inner side borders
Make 2.

7. Stitch the inner top and bottom borders to the top and bottom edges of the quilt. Remove the paper from the stitched seam allowances. Press the seam allowances open. Stitch the inner side

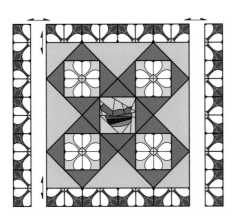

borders to the sides of the quilt. Remove the paper from the stitched seam allowance. Press the seam allowances open.

8. Stitch the outer side borders to the quilt sides. Remove the paper from the stitched seam allowances. Press the seam allowances open. Stitch the outer top and bottom borders to the top and bottom edges of the quilt. Remove the paper from the stitched seam allowance. Press the seam allowances open.

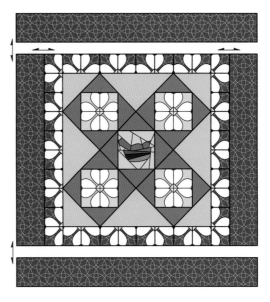

9. Remove the remaining paper foundations.

10. Following the instructions in "Preparing for Quilting" on page 13, layer the quilt top with batting and backing.

11. Quilt as desired.

12. Refer to "Making and Applying Binding" on pages 14–15 to make the binding and bind the quilt edges.

13. Stitch the bead to the bird block as indicated in the block pattern on page 20.

Rose Garden

ROSE GARDEN *by Jodie Davis, 2000, Canton, Georgia, 36" x 36".*

Materials

42"-wide fabric

- 2 yds. yellow print for block backgrounds
- ¼ yd. *each* (or scraps) of 6 or more assorted red prints for rose petals
- ⅛ yd. *each* (or scraps) of 6 or more assorted pink prints for rose centers
- ⅛ yd. *each* (or scraps) of 6 assorted green prints for rose leaves
- ½ yd. green print for ivy
- ¼ yd. blue print for inner border
- 1 yd. multicolor floral print for outer border and binding
- 40" x 40" piece of batting
- 1⅜ yds. of fabric for backing

Cutting

From the blue print, cut:

2 strips, each 1" x 24½", for inner side borders
2 strips, each 1" x 25½", for inner top and
 bottom borders

From the multicolor floral print, cut:

2 strips, each 6" x 25½", for outer side borders
2 strips, each 6" x 36½", for outer top and
 bottom borders
4 strips, each 2½" x 42", for binding

From the backing fabric, cut:

1 piece, 40" x 40"

Quilt Top Assembly

1. Refer to "Transferring the Patterns" on page 7 and the chart below to prepare the foundations.

Block Name	Number to Trace
Ivy II (page 52)	12
Rose I (page 58)	80 subunits
Rose II (page 59)	4 subunits

2. To piece each Ivy II block, refer to "Basic Paper Piecing" on pages 8–10 and "Paper Piecing Curved Seams" on pages 10–12. Follow the "Joining Sequence" instructions that appear on the same page as the pattern to assemble the blocks.

3. To piece the Rose I and Rose II subunits, refer to "Basic Paper Piecing" on pages 8–10 and "Paper Piecing Curved Seams" on pages 10–12. Follow the illustration that appears on the same page as the Rose I pattern to assemble 4 subunits into a complete flower. Make 20 Rose I blocks. Leave the Rose II subunits separate.

4. Assemble the Rose I blocks, Rose II subunits, and Ivy II blocks into 6 rows as shown. Stitch the blocks into rows. Stitch the rows together.

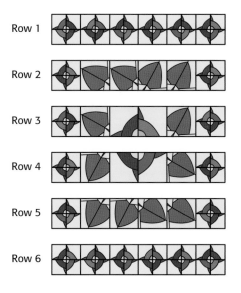

5. Stitch the inner side border strips to the quilt sides. Remove the paper from the stitched seam allowances. Press the seam allowances open. Stitch the inner top and bottom border strips to the top and bottom edges of the quilt. Remove the paper from the stitched seam allowances. Press the seam allowances open.

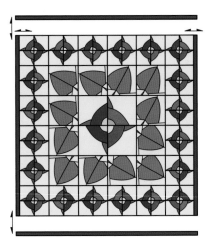

6. Remove the remaining paper foundations.

7. Stitch the outer side border strips to the quilt sides. Press the seam allowances toward the outer border strips. Stitch the outer top and bottom border strips to the top and bottom edges of the quilt. Press the seam allowances toward the outer border strips.

8. Following the instructions in "Preparing for Quilting" on page 13, layer the quilt top with batting and backing.

9. Quilt as desired.

10. Refer to "Making and Applying Binding" on pages 14–15 to make the binding and bind the quilt edges.

STUDENT TIPS

"Sew from the outer edges toward the point. This helps to keep the points sharp and prevents the machine from pulling on the pieces and distorting the block."

—*Wanda Jewell*

"Use a pair of tweezers to gently pull the little triangle pieces of paper out of the overlapping seams. Remember: We are trying to keep the bulk out of the seams as we go."

—*Wanda Jewell*

"Before removing the paper, go over the seams with a tracing wheel. This will help to break the paper, thereby making it easier to remove."

—*Lorrie Shaw*

Lazy Daisy

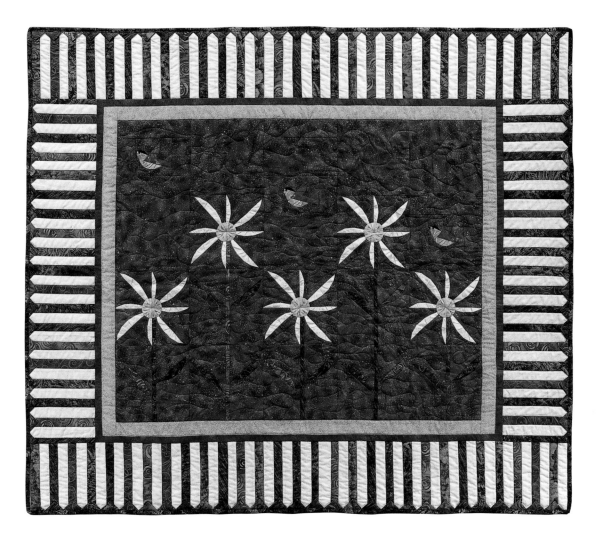

LAZY DAISY *by Jodie Davis, 2000, Canton, Georgia, 50½" x 58½".*

Materials

42"-wide fabric

- 3 yds. blue print for center block backgrounds and filler pieces
- ⅜ yd. white solid or print for daisy petals
- ¼ yd. green print for daisy leaves and stems
- Scraps of assorted yellow prints for daisy centers
- ¼ yd. *each* (or scraps) of 1 light red print and 1 dark red print for birds
- Scrap of black solid for bird head
- Scrap of brown solid for bird beak
- ⅜ yd. yellow print for inner border
- ¼ yd. red print for middle border
- 2 yds. white solid or print for outer border fence pickets
- 2½ yds. total of assorted green prints for outer border background and binding
- 55" x 63" piece of batting
- 3¾ yds. fabric for backing
- Three 3mm black beads for bird eyes

Cutting

From the blue print, cut:

6 rectangles, each 2½" x 4½", for filler pieces

3 strips, each 2½" x 8½" for filler pieces

2 rectangles, each 6½" x 8½", for filler pieces

1 square, 8½" x 8½", for filler piece

1 rectangle 8½" x 12½", for filler piece

1 rectangle 8½" x 16½", for filler piece

From the yellow inner border print, cut:

2 strips, each 2" x 40½", for inner top and bottom borders

2 strips, each 2" x 35½", for inner side borders

From the red middle border print, cut:

3 strips, each 1¼" x 42", for middle top and bottom borders

2 strips, each 1¼" x 37", for middle side borders

From the binding fabric, cut:

6 strips, each 2½" x 42"

Quilt Top Assembly

1. Refer to "Transferring the Patterns" on page 7 and the chart below to prepare the foundations.

Block Name	Number to Trace
Flying Bird (page 43)	3
Daisy II, head (page 35)	5
Daisy II, leaves and stems (page 35)	7
Picket Fence (page 56)	26

2. To piece the Flying Bird, Daisy head, and Daisy leaves and stems, refer to "Basic Paper Piecing" on pages 8–10 and "Paper Piecing Curved Seams" on pages 10–12. Follow the "Joining Sequence" instructions that appear on the same page as the patterns to assemble the blocks. Keep the Daisy heads and leaves-and-stem units separate. Do not piece the fence blocks at this time.

3. Stitch a 2½" x 4½" filler piece to the sides of each Flying Bird block. Press the seam allowances toward the filler pieces.

Make 3.

4. Assemble the pieced blocks and filler pieces vertically into rows 1, 2, and 3 as shown. Press the seam allowances toward the filler pieces. Stitch the blocks into rows, then stitch the rows together.

5. Assemble the pieced blocks and filler pieces vertically into rows 4 and 5 as shown. Stitch the blocks into rows, then stitch the rows together. Stitch the remaining filler pieces to the top of the row 4/5 unit. Press the seam allowance toward the filler piece.

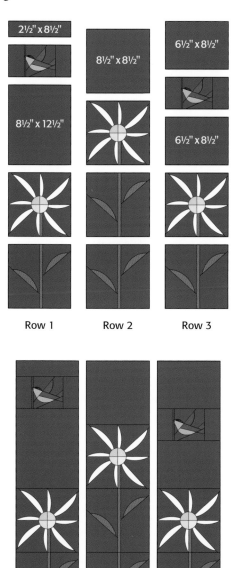

Row 1 Row 2 Row 3

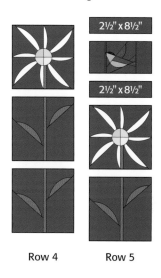

Row 4 Row 5

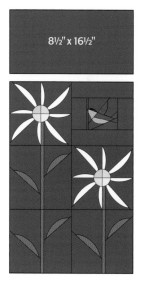

6. Stitch the row 1/2/3 unit to the row 4/5 unit.

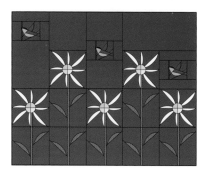

7. Stitch the inner top and bottom border strips to the top and bottom edges of the quilt. Remove the paper from the stitched seam allowances. Press the seam allowances open. Stitch the inner side border strips to the quilt sides. Remove the paper from the stitched seam allowances. Press the seam allowances open.

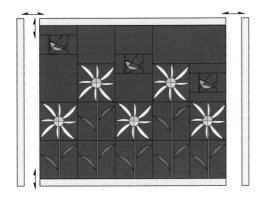

8. Stitch the middle top and bottom border strips together end to end to make one long strip. From the pieced strip cut 2 segments, each 1¼" x 43½". Stitch the strips to the top and bottom edges of the quilt. Remove the paper from the stitched seam allowances. Press the seam allowances open. Stitch the middle side border strips to the quilt sides. Remove the paper from the stitched seam allowances. Press the seam allowances open.

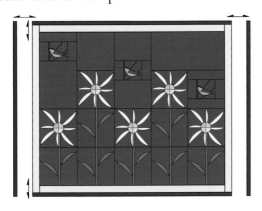

9. To make the outer border side strips, tape 5 Picket Fence block patterns together end to end, overlapping the seam allowances where the blocks meet. Cut 3 strips off the end of the pattern, leaving ¼" beyond the last strip for seam allowance. Make 2. To make the outer border top and bottom strips, tape 8 Picket Fence block patterns together end to end, aligning the seam allowances where the blocks meet. Cut 6 strips off the end of the pattern, leaving ¼" beyond the last strip for seam allowance. Make 2.

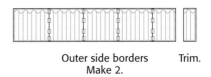

Outer side borders Trim.
Make 2.

Outer top and bottom borders Trim.
Make 2.

10. Refer to "The 'V' Trick" on page 12 to piece the Picket Fence blocks. Measure the side border strips and be sure they measure 37½" long; adjust if necessary. Measure the top and bottom border strips and trim to 59".

11. Stitch the outer side border strips to the quilt sides. Remove the paper from the stitched seam allowances. Press the seam allowances open. Stitch the outer top and bottom border strips to the top and bottom edges of the quilt. Remove the paper from the stitched seam allowances. Press the seam allowances open.

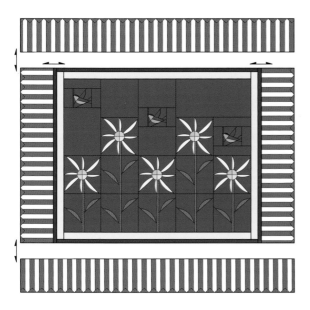

12. Remove the remaining paper foundations.

13. Cut the backing fabric in half widthwise. Stitch the pieces together lengthwise. Trim the pieced backing to 55" x 63".

14. Following the instructions in "Preparing for Quilting" on page 13, layer the quilt top with batting and backing.

15. Quilt as desired.

16. Refer to "Making and Applying Binding" on pages 14–15 to make the binding and bind the quilt edges.

17. Stitch the beads to the bird blocks as indicated in the block pattern on page 43.

Christine's World

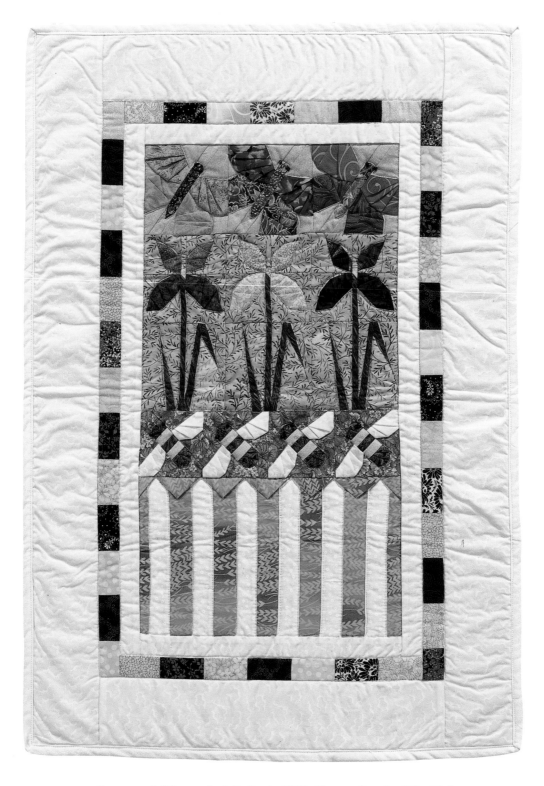

CHRISTINE'S WORLD *by Jodie Davis, 2000, Canton, Georgia, 22" x 32."*

Materials

42"-wide fabric

- ¼ yd. green print for fence background
- ⅛ yd. blue-green print for bee background
- ⅜ yd. blue print for flower background
- ¼ yd. blue print for butterfly background
- ¼ yd. white print for fence pickets
- ⅛ yd. *each* (or scraps) of 4 assorted brown prints for bee and butterfly bodies
- ⅛ yd. *each* (or scraps) of 5 assorted yellow prints for bee bodies, iris centers, and pieced middle border
- ⅛ yd. *each* (or scraps) of 2 assorted purple prints, 2 assorted blue prints, and 2 assorted yellow prints for iris petals
- ¼ yd. of green print for iris stems and leaves
- ⅛ yd. *each* (or scraps) of 2 assorted gold prints, 2 assorted blue prints, and 2 assorted red prints for butterfly wings
- ¼ yd. *each* (or scraps) of four assorted black prints for pieced middle border
- 1 yd. of white print for bee wings, inner border, outer border, and binding
- 26" x 36" piece of batting
- ⅞ yd. of fabric for backing
- Six 3mm black beads for butterfly eyes
- Eight 4mm black beads for bee eyes

Cutting

From the white inner border, outer border, and binding fabric, cut:

2 strips, each 1½" x 12½", for inner top and bottom borders

2 strips, each 1½" x 24½", for inner side borders

2 strips, each 3½" x 16½", for outer top and bottom borders

2 strips, each 3½" x 32½", for outer side borders

3 strips, each 2½" x 42", for binding

From the assorted yellow prints for the pieced middle border, cut a total of:

21 rectangles, each 1½" x 2½"

From the assorted black prints for the pieced middle border, cut a total of:

18 rectangles, each 1½" x 2½"

Quilt Top Assembly

1. Refer to "Transferring the Patterns" on page 7 and the chart below to prepare the foundations.

Block Name	Number to Trace
Bee II (page 17)	4
Butterfly I (page 21)	3
Iris (page 49)	3
Picket Fence (page 56)	2

2. To piece the Bee II, Butterfly I, and Iris blocks, refer to "Basic Paper Piecing" on pages 8–10 and "Paper Piecing Curved Seams" on pages 10–12. Follow the "Joining Sequence" instructions that appear on the same page as the patterns to assemble the blocks.

3. Tape the Picket Fence patterns together end to end, overlapping the seam allowances where the blocks meet. Cut 3 strips off the end of the pattern, leaving ¼" for seam allowance. Refer to "The 'V' Trick" on page 12 to piece the Picket Fence blocks. Measure the fence unit width and be sure it measures 12½". Trim if necessary.

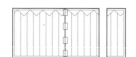

Trim 3 pickets, leaving a
¼"-wide seam allowance.

4. Assemble the pieced blocks into 4 horizontal rows as shown. Stitch the blocks into rows. Stitch the rows together.

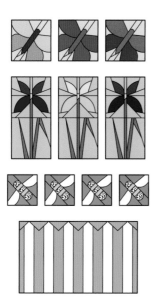

5. Sew the inner top and bottom border strips to the top and bottom edges of the quilt. Remove the paper from the stitched seam allowances. Press the seam allowance open. Stitch the inner side border strips to the quilt sides. Remove the paper from the stitched seam allowances. Press the seam allowance open.

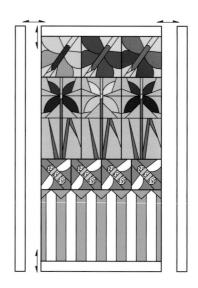

6. Remove the remaining paper foundations.

7. Beginning and ending with a yellow rectangle, alternately stitch together 4 yellow and 3 black 1½" x 2" rectangles for the middle top and bottom border strips. Make 2. Alternately stitch 7 yellow and 6 black 1½" x 2" rectangles together for a side border strip, beginning and ending with a yellow rectangle. Make 1. Beginning and ending with a black rectangle, stitch together 7 black and 6 yellow 1½" x 2" rectangles for the remaining side border strip. Make 1.

Top and bottom borders
Make 2.

Side border
Make 1.

Side border
Make 1.

8. Stitch the middle top and bottom border strips to the top and bottom edges of the quilt. Press the seam allowances toward the border strips. Stitch the middle side border strips to the quilt sides. Press the seam allowances toward the border strips.

9. Stitch the outer top and bottom border strips to the top and bottom edges of the quilt. Press the seam allowances toward the border strips. Stitch the outer side borders to the quilt sides. Press the seam allowances toward the border strips.

10. Following the instructions in "Preparing for Quilting" on page 13, layer the quilt top with batting and backing.

11. Quilt as desired.

12. Refer to "Making and Applying Binding" on pages 14–15 to make the binding and bind the quilt edges.

13. Stitch the 4mm beads to the bee blocks and the 3mm beads to the butterfly blocks as indicated in the block patterns on pages 17 and 21.

Window Box Garden

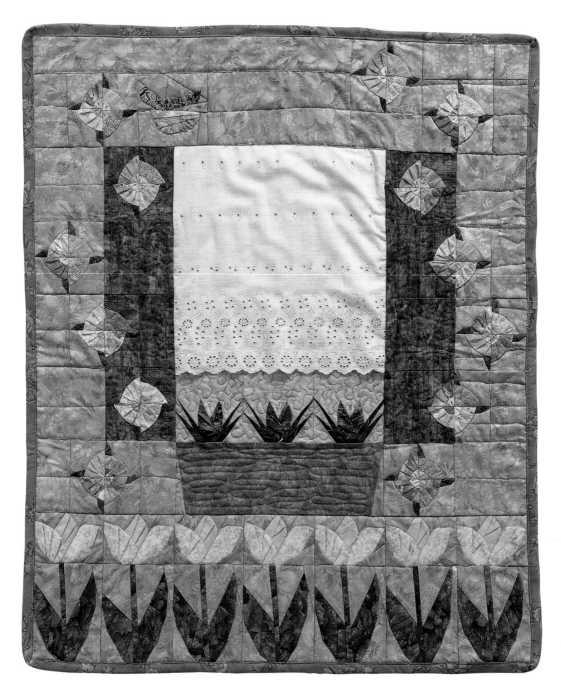

WINDOW BOX GARDEN *by Jodie Davis, 2000, Canton, Georgia, 28" x 32"*.

Materials

42"-wide fabric

- ¼ yd. *each* (or scraps) of 6 assorted yellow prints for tulips and crocuses
- ¼ yd. *each* (or scraps) of 8 assorted pink prints for roses
- ⅛ yd. (or scrap) of purple print for crocuses
- ¼ yd. green print for tulip, crocus, and rose leaves and stems
- Scrap of blue print for bird
- Scraps of 5 assorted brown prints for bird's nest
- ⅜ yd. light blue print for windowpane and crocus block backgrounds
- ⅜ yd. green print for shutters
- 1 yd. light gray print for house "siding"
- 4½" x 12½" rectangle of brown print for window box
- ½ yd. white eyelet fabric with one finished edge
- 1⅛ yds. fabric for backing
- 32" x 36" piece of batting
- ⅜ yd. medium gray print for binding
- 3mm black bead for bird's eye

Cutting

From the light blue print, cut:

1 square, 12½" x 12½", for windowpane

From the green shutter print, cut:

2 squares, each 4½" x 4½"

3 rectangles, each 2½" x 4½"

From the light gray print, cut:

1 square, 2½" x 2½"

1 strip, 2½" x 6½"

9 rectangles, 2½" x 4½"

4 squares, each 4½" x 4½"

1 rectangle, 6½" x 8½"

2 Template A (page 94)

From the white eyelet, cut:

1 square, 12½" x 12½", using the fabric's finished edge for one side of the square

From the backing fabric, cut:

1 piece, 32" x 36"

From the medium gray print, cut:

3 strips, each 2½" x 42", for binding

Quilt Top Assembly

1. Refer to "Transferring the Patterns" on page 7 and the chart below to prepare the foundations.

Block Name	Number to Trace
Bird in Nest (page 19)	1
Crocus (page 28)	3
Rose I (page 58)	52 subunits
Tulip (page 62)	7

2. To piece the Bird in Nest, Crocus, and Tulip blocks, refer to "Basic Paper Piecing" on pages 8–10 and "Paper Piecing Curved Seams" on pages 10–12. Follow the "Joining Sequence" instructions that appear on the same page as the patterns to assemble the blocks.

3. Make 18 Rose I subunits using the green shutter print for the background and 34 subunits using the light gray print for the background. Join the subunits to make the blocks shown.

Make 3.

Make 7.

Make 3.

4. To make the window box, make a mark ⅞" in from the lower edge corners. Draw a line from the mark to the upper edge corner, tapering to nothing. Cut the marked section away from the rectangle.

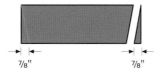

5. Stitch the Template A pieces to each side of the window box.

6. Stitch the 3 Crocus blocks together horizontally. Sew the crocus unit to the top of the window box. Stitch the 12½" x 12½" windowpane piece to the top of the crocus/window box unit. Lay the eyelet square over the windowpane section, right side up, aligning the windowpane and eyelet top edges. Baste in place along the top and side edges.

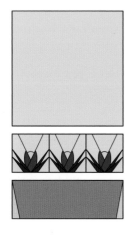

7. Stitch the pieced blocks into 3 rows as shown. Stitch the rows together.

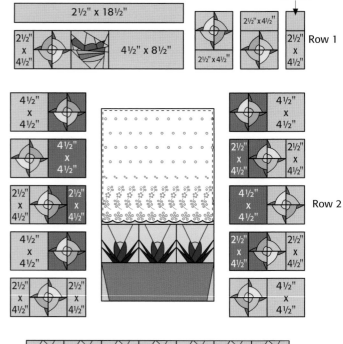

Row 1

Row 2

Row 3

8. Following the instructions in "Preparing for Quilting" on page 13, layer the quilt top with batting and backing.

9. Quilt as desired.

10. Refer to "Making and Applying Binding" on pages 14–15 to make the binding and bind the quilt edges.

¼" seam allowance

Template A
Cut 1 and 1 reversed.

← straight of grain →

RESOURCES

Mail-Order Shopping

NOTHING BEATS visiting a quilt shop to see all the latest luscious fabrics and sewn samples, not to mention the camaraderie of being with fellow quilt lovers. Believe me, I help the local shops thrive. But there is never enough fabric and quilting goodies for my appetite, so I often use mail-order and online quilting resources and services. Here are the resources I use. I recommend each of them without hesitation.

For those of you who are hesitant about ordering online, the resources listed all have secure servers to protect your credit card information; however, if you are not convinced that this is safe, call with your order and credit card information. I have corresponded with each of them and have heard only excellent reviews from other online quilters.

> **TIP**
>
> When shopping for fabric online, I print out a picture of the fabric swatches so that I have a visual record of what I ordered. Then I staple the printout to my quilt design so that I remember exactly how I intended to use the fabric(s) in the quilt.

Supplies

BIGHORN QUILTS
529 Greybull Ave.
PO Box 566
Greybull, WY 82426
(877) 586-9150
www.bighornquilts.com

At the Worldwide Online Fabric Store, fabric takes center stage, and lots of it is at I-can't-resist prices.

CONNECTING THREADS
PO Box 8940
Vancouver, WA 98668-8940
(800) 574-6454
www.connectingthreads.com

Their online Web site is full of books, patterns, fabrics, and most every quilting tool imaginable, all at discounted prices.

EQUILTER.COM
4581 Maple Court
Boulder, CO 80301
(303) 516-1615
www.eQuilter.com

A Web site specializing in Asian-Pacific and contemporary fabrics.

HANCOCK'S OF PADUCAH
3841 Hinkleville Road
Paducah, KY 42001
(800) 845-8723
www.Hancocks-Paducah.com

A wide selection of the latest fabrics plus threads, quilting gadgets, batting, and more, all at great prices. Check out both the online catalog and mail-order catalog; one may have fabrics the other doesn't.

KEEPSAKE QUILTING
Route 25B
PO Box 1618
Centre Harbor, NH 03226-1618
(800) 865-9458
www.keepsakequilting.com

This hefty little catalog is chock-full of all the latest and tried-and-true quilt notions, gadgets, patterns, books, and fabric, as well as handy Fabric Medleys. No wonder it is entitled "The Quilter's Wishbook."

PINE TREE QUILTWORKS, LTD.
585 Broadway
South Portland, ME 04106
(207) 799-7357
www.pinetree.quiltworks.com

Everything a quilter needs, including a wonderful selection of fabrics and every ruler and notion imaginable, all at discounted prices.

QUILT-A-WAY FABRICS
PO Box 163
Westminster Station, VT 05159
(802) 722-4743
www.quiltaway.com

A full service quilt shop, Quilt-a-way's mail-order site offers a great selection of fabrics at low prices, including many batiks.

QUILTS AND OTHER COMFORTS
B2500
Louisiana, MO 63353-7500
(800) 881-6624
www.quiltsonline.com

"The catalog for quilt lovers" focuses on fabrics and patterns with a good selection of popular books and quilt tools, as well as some nice gift-type items.

Cyberspace

The following are a few starting points for exploring quilting and foundation piecing in cyberspace.

ABOUT.COM
www.quilting.about.com

The mission of About.com is to be *the* place to go to learn about any topic. Each area is devoted to a specific interest and is hosted by a real, live, accessible human being. The quilting area, hosted by Susan Druding, is a resource for all facets of quilting, offering how-to directions, answers to frequently asked questions, sources, links to other sites, and much more.

JUDY SMITH'S QUILTING, NEEDLEARTS AND ANTIQUES PAGE
www.quiltart.com/judy

Judy has used the Internet for a long time and has a highly acclaimed site of great quilting links. Start your search with Judy's site, and you will quickly accrue a long list of bookmarked favorites!

PC PIECERS
www.Geocities.com/PCpiecers

Dedicated specifically to foundation piecing, the PC Piecers site has a lot of great information, patterns, and activities.

PLANET PATCHWORK
www.planetpatchwork.com

Check out their schedule of online classes and rock-bottom prices on quilting software.

THE QUILT CHANNEL
www.quiltchannel.com

The Quilt Channel aims to be the most comprehensive guide to quilting links anywhere. Links include Shopping, Major Quilting Sites, Tips and Techniques, and lots more.

QUILTNET
www.quilt.net

QuiltNet is your gateway to an array of craft-related Web pages covering the worlds of quilting, weaving, and sewing.

THE WORLD WIDE QUILTING PAGE
http://mail.kosmickitty.com/Main QuiltingPage.html

This site features just about everything you need to know about quilting, as well as lots of fun things to do.

ZIPPY DESIGNS PUBLISHING
Home of *The Foundation Piecer* Magazine
Rural Route 1, Box 187M
Newport, VA 24128
(888) 544-7153
www.zippydesigns.com

The Web site for Zippy Designs is a great resource. Find foundation-piecing instructions, block patterns, information about *The Foundation Piecer* magazine and products, and much more at this site.

ABOUT THE AUTHOR

JODIE DAVIS has been designing and sharing her work for the last twelve years through the more than twenty books she has written. And that's exactly what she's happiest doing—dreaming up and trying out new quilting ideas in her studio. Along with Bill, her husband of barely a year, Jodie is an avid gardener. She also collects rubber duckies and cuckoo clocks. Jodie and Bill live in the foothills of the North Georgia mountains, sharing their home with a smiling Dalmatian, four Velcro cats, and an Indian ringneck parakeet that loves the trimmings left over from paper piecing. Visit Jodie's web site at www.iejodie.com.